IMAGES
of America

ALEXANDRIA
1861–1865

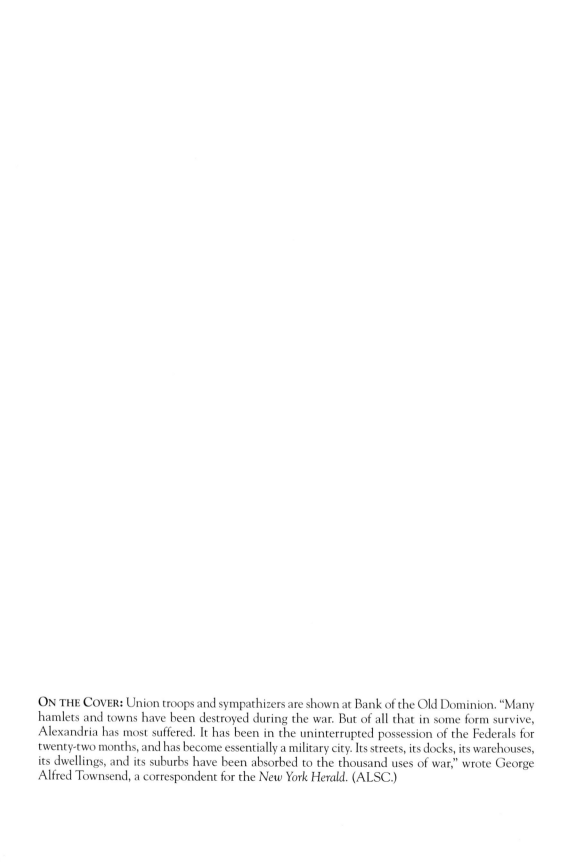

IMAGES
of America

ALEXANDRIA
1861–1865

Charles A. Mills and Andrew L. Mills

ARCADIA
PUBLISHING

Published by Arcadia Publishing
Charleston, South Carolina

Printed in the United States of America

Library of Congress Catalog Card Number: 2007942614

For all general information contact Arcadia Publishing at:
Telephone 843-853-2070
Fax 843-853-0044
E-mail sales@arcadiapublishing.com
For customer service and orders:
Toll-Free 1-888-313-2665

Visit us on the Internet at www.arcadiapublishing.com

CONTENTS

ACKNOWLEDGMENTS

We are extremely grateful for the help and encouragement of the staff of the Alexandria Library Special Collections branch (ALSC). We are especially grateful to George Combs, branch manager, and Julie Ballin Patton, photographs librarian. We salute their consummate professionalism.

We gratefully acknowledge the research done by previous historians on the subject, including James Barber (*Alexandria in the Civil War*), Jeremy Harvey (*Occupied City: A Portrait of Civil War Alexandria*), William B. Hurd (*Alexandria, Virginia 1861–1865*), and William Francis Smith and Michael Miller (*A Seaport Saga*). We hope that this book will enrich and add a new dimension to the fine work that these historians have already done.

We are grateful to the City of Alexandria for its commitment to making America's historical legacy a real and important part of the everyday lives of its people.

Please note that the Library of Congress is referenced throughout as LOC.

INTRODUCTION

In the 1850s, Alexandria was the commercial center for all of northern Virginia and boasted a busy waterfront, a commercial canal, and expanding railway traffic. Alexandria took great pride in being the "hometown" of George Washington. It was on the steps of Gadsby's Tavern (the City Hotel in 1861) that Light Horse Harry Lee declared George Washington "first in war, first in peace, first in the hearts of his countrymen."

Alexandria, with its long history of service to the Union, initially opposed secession. Many citizens would gladly have remained in the Union or remained neutral, but were also prepared to cast their lot with the Confederacy if it came to war. The tide turned toward secession on April 12, 1861, when South Carolina fired on Fort Sumter and Lincoln called for 75,000 volunteers to crush the rebellion.

Long before dawn on the morning of May 24, 1861, eight Union regiments crossed the Potomac River to seize Alexandria and Arlington Heights. By 2:00 a.m., a large, luminous moon shimmered over the river as federal long boats touched their oars into the muddy waters. For an hour, muffled oars pulled against the river. The red-trousered New York Zouaves sat tensed in silent anticipation. They docked quickly and quietly unloaded into the deserted streets of Alexandria.

The entrance of the federals was unopposed. Col. Elmer Ellsworth led his men down the empty streets until he came to a hotel flying the Confederate flag. Followed by his soldiers, Ellsworth went inside, hurried to the roof, and with a knife borrowed from a private soldier, cut down the emblem of rebellion. In a shadowy hallway, he met the proprietor of the inn, James Jackson. Jackson produced a shotgun and killed Ellsworth. War had come to Virginia. For the next four years, Alexandria was an occupied city and a major supply hub for the Union army.

Alexandria was an important railroad center. The Union army seized the railroads immediately. Brig. Gen. Herman Haupt, a railroad construction engineer, revolutionized military transportation in this country and was one of the unsung heroes of the Civil War. He repaired and fortified war-damaged railroad lines in the vicinity of Washington, arming and training the railroad staff, and improved telegraph communications along the lines. His well-organized trains kept the Union army supplied and carried thousands of wounded to hospitals. Haupt's nemesis was Confederate raider John S. Mosby, who, with fewer than 250 men, immobilized 30,000 Union troops by his daring raids. It seemed that the "Grey Ghost" was everywhere. He destroyed railway tracks, robbed Union paymasters, captured pickets, and shot down stragglers. Mosby single-handedly crossed Long Bridge into Washington City in the full light of day and returned unharmed to Virginia. Alexandria's strategic location on the Potomac River was as important as its railroads. Alexandria was always a busy port. As relations between North and South deteriorated, the Union press accused Virginians of stopping small ships headed for Washington. The *Alexandria Gazette* accused federal authorities of seizing ships headed for Alexandria. After the federal occupation, Alexandria businessman Benjamin Barton wrote the following:

"Alexandria has more of a business like appearance now. . . . Indeed it is quite a stirring place, of course most of the business has some connection with the National government,

all the supplies of the armies, in this section of Virginia, arrive here by land and by water, the great number of steamboats, sloops, schooners and brigs required, arriving at this port, and passing up to Washington, has the appearance of a fleet opposite our City."

One of the wartime highlights for Alexandria was the arrival of Imperial Russian warships on a goodwill visit.

After the federal occupation, Alexandria became an important hospital center for the Union army. Four churches and many large houses were converted into hospitals, totaling 14 facilities in all. These institutions were overcrowded and often unsanitary, especially after a major battle. One volunteer chaplain recorded, "Through all the wards confused heaps of torn and dirty clothes and piles of bloody bandages, tired attendants doing their best to make comfortable the poor fellows torn and mangled with shot and shell in every imaginable way."

Alexandria was an essential link in the chain of fortifications guarding Washington. Ringing the federal capital were 68 major forts connected by military roads and rifle trenches—the Union's last line of defense against the Confederate army. This formidable network of earthwork fortifications bristled with more than 900 cannons and 98 mortars. After the war, when asked why the Confederate army did not attack Washington after the Second Battle of Manassas in 1862, Robert E. Lee said, pointing to Fort Ward, "I could not tell my men to take that fort when they had nothing to eat for three days."

It was not only the city of Alexandria that suffered during the war, but all of northern Virginia. Crops were trampled. Fences were used for firewood. Livestock was confiscated. Most of the standing trees were cut to supply building materials or facilitate the firing of artillery. Rifle trenches and ammunition bunkers were dug along the ridges and high ground. Barns, outbuildings, and private homes were occupied, damaged, or destroyed to accommodate the needs of the Union army.

With the end of the war, the Union army gathered for one last grand victory parade in Washington. In May 1865, Anne Frobel wrote the following:

"Today we see tents and camps spring up in every quarter Sherman's army coming in. The roads filled with soldiers as far back as we can see through the woods, coming-coming-coming, thousands and tens of thousands. I hardly thought the world contained so many men and the wagons, O the wagons, long lines of white wagons coming by roads and crossroads. . . . Tomorrow there is to be a 'grand review' of the 'grand' U.S. Army at Washington and great has been the stir of preparation. . . . Rose Hill is literally covered with Sherman's army and such immense numbers of splendid horses and mules."

On July 7, 1865, the military governor of Alexandria put down his duties. Normalcy began to return after four years of war.

This book represents the most complete photographic history of Alexandria, Virginia, during the period of the Civil War currently in existence. The photographs and illustrations in the book are taken from three rare collections: the Civil War Collection of the Library of Congress, the William Francis Smith Collection of the Alexandria Library Special Collections branch, and the Mollie Somerville Collection of the Alexandria Library Special Collections branch. Almost all are actual Civil War–era photographs. In a few instances where Civil War photographs of specific significant locations were not available, we have selected photographs of the location at the nearest point in time to the Civil War as possible.

One

BEFORE THE STORM

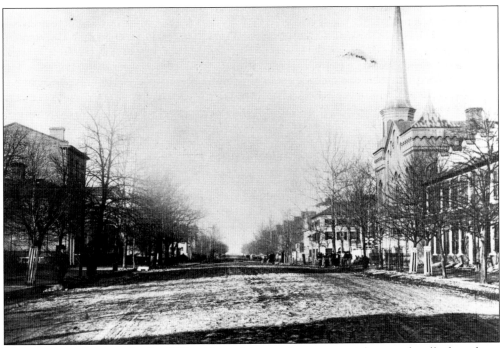

WASHINGTON STREET. In the 1850s, Alexandria was the commercial center for all of northern Virginia. Between 1850 and 1860, its population grew from 8,795 to 12,652. A correspondent of the Rockingham Register wrote of the city, "The animation and occupation which enlivens her railroad depots, her wharves and canal basin, as well as the bustle and hum of her streets, prove this worthy daughter of the Old Dominion is in a fair way to rank, ere long, among the most prosperous cities in the land." Alexandria, with its long history of service to the Union, initially opposed secession. On April 12, 1861, however, when South Carolina fired on Fort Sumter, the city turned toward secession. (ALSC.)

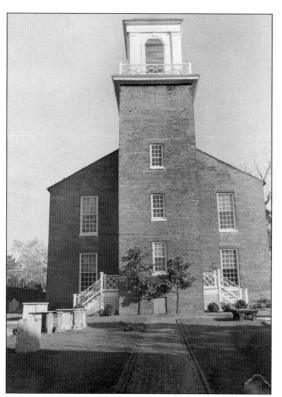

PRESBYTERIAN MEETING HOUSE. Scottish and Ulster-Scottish settlers to the Alexandria area in the 18th century soon created positions for themselves, primarily as merchants and sea traders. They took a prominent part in founding the town of Alexandria and a leading role in forming the Presbyterian church of the new community. (ALSC.)

HALLOWELL SCHOOL. In 1824, Benjamin Hallowell founded a preparatory school where he also gave evening lectures to adults and private lessons to girls. By 1830, the Alexandria Boarding School had become successful, catering to many students from the families of prominent citizens. Robert E. Lee was one of those students. Hallowell ran the school until it was sold in 1858. (ALSC.)

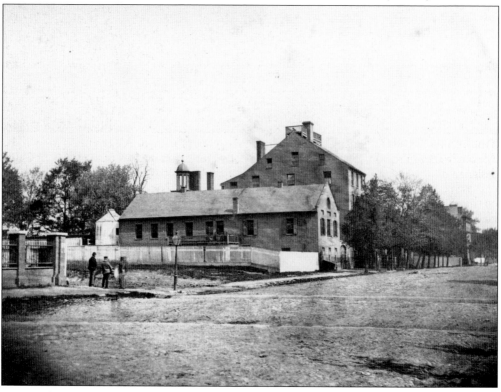

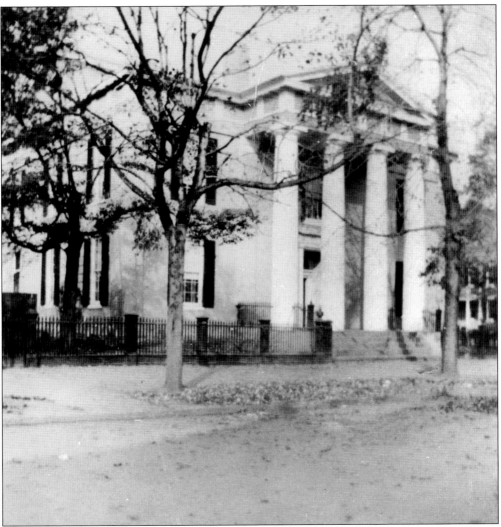

THE LYCEUM. In 1834, Benjamin Hallowell and six other prominent Alexandrians formed the Alexandria Lyceum and began offering a series of lectures and debates on a variety of topics designed to provide for the "education and edification of the citizenry." By 1839, the popularity of these programs necessitated the construction of a new hall. The *Alexandria Gazette* reported, on the evening of December 12, 1839, "The Alexandria Lyceum opened at the new and beautiful Hall, on Washington street." The Lyceum became a major cultural institution in the town and boasted a large second-floor meeting hall as well as space for a 5,000-volume public lending library. The structure was described as a "fine building with a pediment front supported by four fluted columns . . . surrounded by a beautiful yard of flowers and ornamental shrubbery." (ALSC.)

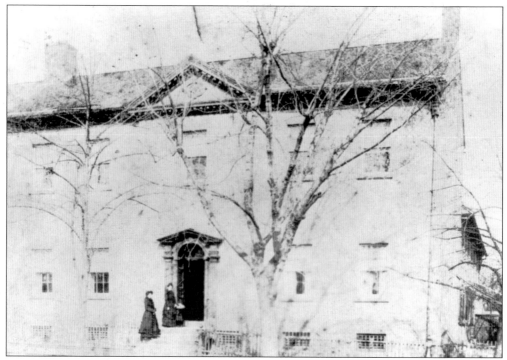

LEE'S BOYHOOD HOME. The Lee family had a large presence in Alexandria. The house at 429 North Washington Street became a shrine to Light Horse Harry Lee, the man who proclaimed Washington "first in war, first in peace, first in the hearts of his countrymen." Gen. Robert E. Lee lived at 607 Oronoco Street (pictured above) as a boy and again as a young cadet. (ALSC.)

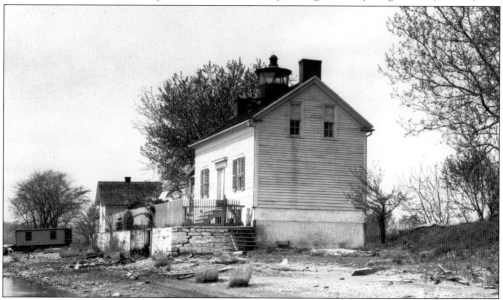

JONES POINT LIGHTHOUSE. In 1852, the Lighthouse Board received a Congressional appropriation of $5,000 to purchase land and erect a beacon at Jones Point on the Potomac River. Whale oil lamps were originally used to power the beacon at Jones Point, but in 1858, the board allowed an Alexandria gas company to extend lines to the station. (ALSC.)

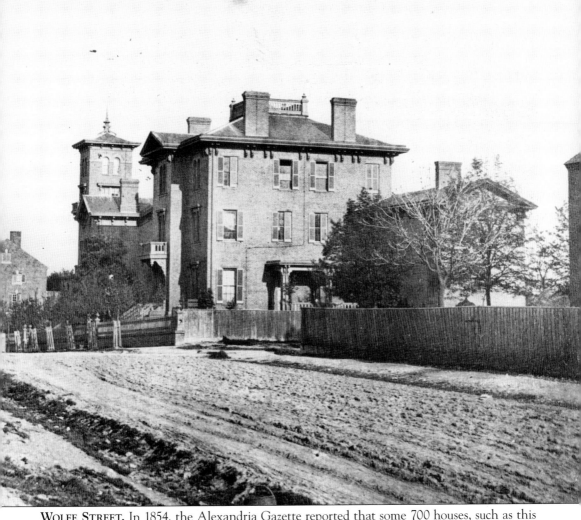

WOLFE STREET. In 1854, the Alexandria Gazette reported that some 700 houses, such as this imposing structure on Wolfe Street, had been built in the city since 1850. "The stagnation and dullness which had prevailed here before has given way to economic prosperity. Houses which erst went begging for occupants are filled to overflowing. . . . The miserable skeletons of antiquated buildings are metamorphosed into large, neat and substantial edifices which are useful and ornamental." By 1860, the *Alexandria Gazette* could report that 1860 had "shown an increase in all departments of trade and commerce over the many prosperous years since retrocession." Infrastructure improvements during the 1850s included gas lighting and a public water works. In the 1850s, Alexandria was also transformed into a major railroad hub with four lines. (ALSC.)

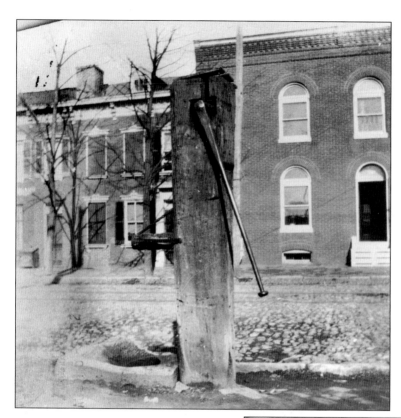

WATER SERVICE. By the 1850s, Alexandria was modernizing. The population rose from 8,795 in 1850 to 12,652 by 1860. In November 1851, some parts of the city had light and gas service, and the city provided water service in 1852. Wholey's Omnibuses and Latham's Omnibuses offered regular bus service to Washington City. (ALSC.)

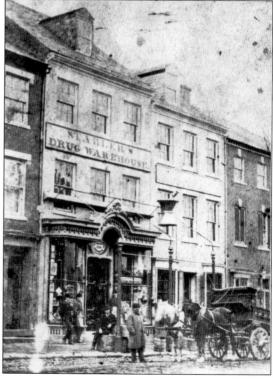

APOTHECARY SHOP. Col. Robert E. Lee was at the apothecary shop on Fairfax Street on October 17, 1859, when he was ordered to command the federal troops sent to Harpers Ferry to suppress the John Brown insurrection. It was also at the apothecary shop, on April 19, 1861, that Lee first read definitive news of Virginia's secession in the *Alexandria Gazette*. (ALSC.)

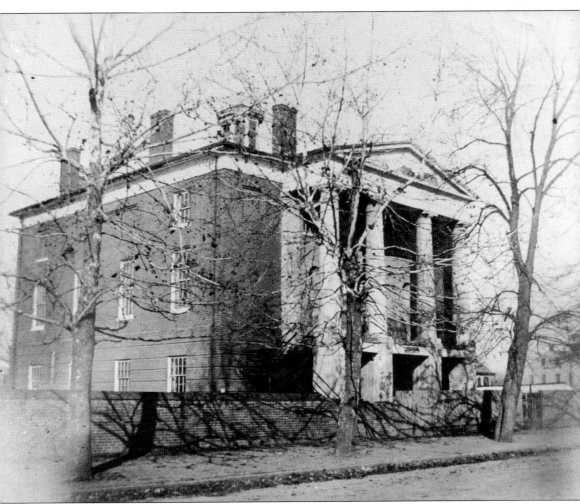

COURTHOUSE. In 1861, Alexandria served as the county seat of Alexandria County, which included present-day Arlington County and the modern city of Alexandria. Beyond the city's boundaries was a rural community. Landowners lived in Washington or the city of Alexandria and visited their country holdings only sporadically. According to the U.S. Census of 1860, the "country part" of Alexandria County contained 1,486 people. There were 251 slaveholders and 982 slaves recorded. A portion of the city of Alexandria and all of current Arlington County were originally in Virginia, then ceded to the federal government to form the District of Columbia, and later retroceded to Virginia in 1846, when the district was reduced in size to exclude the portion south of the Potomac River. The city of Alexandria was re-chartered in 1852. (ALSC.)

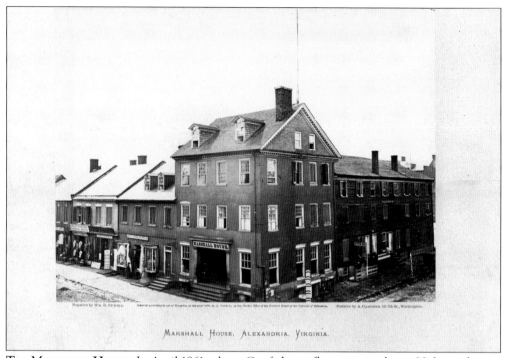

MARSHALL HOUSE, ALEXANDRIA, VIRGINIA.

THE MARSHALL HOUSE. In April 1861, a huge Confederate flag was raised on a 30-foot pole atop the Marshall House. The *Washington Herald* reported, "Senator Wade upon observing it with a glass from the President's room yesterday, expressed his regret to Mr. Lincoln that it should be tolerated; to which Mr. Lincoln replied that he did not think it would wave long." (LOC.)

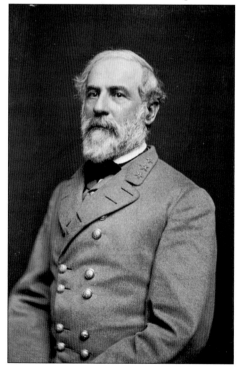

ROBERT E. LEE. Lee attended Christ Church in Alexandria on April 21, 1861. That evening he received a note from a representative of the governor of Virginia, asking him to meet with Governor Lechter at Richmond. The following day he again came to Alexandria and took the train for Richmond, where he accepted appointment as "commander of the military and naval forces of Virginia." (LOC.)

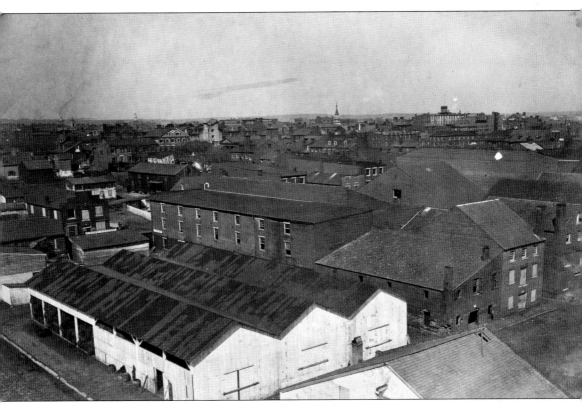

ALEXANDRIA FROM PIONEER MILL. The decade of the 1850s was turbulent. The nation was increasingly polarized. The Compromise of 1850 outlawed the slave trade in the District of Columbia and admitted California as a free state. The Fugitive Slave Act, however, infuriated abolitionists by guaranteeing the rights of slave owners to reclaim slaves who escaped to the North. Isabel Emerson of Alexandria declared, "Virginia is trying to hold on to the Union. I don't know whether I am a secessionist or not, but if this dear old state secedes, I shall too." D. G. Duncan, confidential agent of the Confederate secretary of war, reported on May 2, 1861, "Great excitement here. Troops expected from Washington to give effect to [martial] law. Alexandria unprepared to oppose attack. . . . Merchants here moving goods, furniture, and families to country."(LOC.)

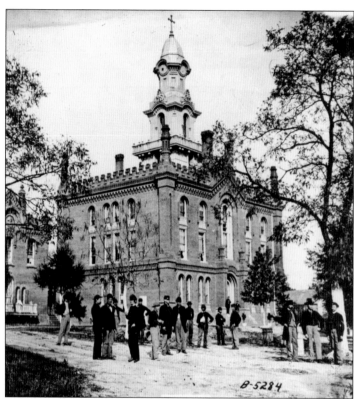

EPISCOPAL SEMINARY. Judith B. McGuire, wife of the headmaster at Episcopal High School, recorded in her diary on May 4, 1861, "Our friends and neighbors have left us. . . . The Theological Seminary is closed; the High School dismissed. . . . Can it be that our country is to be carried on and on to the horrors of Civil War?" (ALSC.)

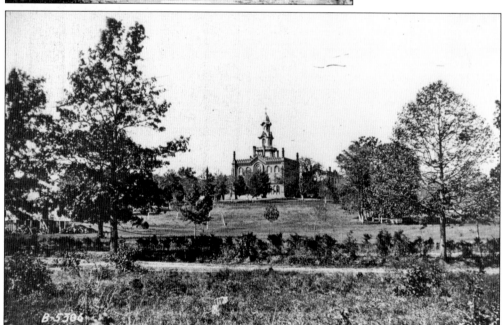

EPISCOPAL SEMINARY, LONG VIEW. On May 10, 1861, Judith B. McGuire wrote, "I heard distinctly the drums beating in Washington. That Capitol of which I had always been so proud! Can it be possible that it is no longer our Capitol? . . . And must this Union, which I was taught to revere, be rent asunder? We are now hoping that Alexandria will not be a landing place." (ALSC.)

Two

OCCUPATION

ELMER ELLSWORTH. On May 24, 1861, federals entered Alexandria unopposed. Col. Elmer Ellsworth led his men down the empty streets until he came to a hotel bearing the Confederate flag. After cutting down the emblem of rebellion, Ellsworth started back for the street with the flag tucked under his arm. In a shadowy hallway, he met the proprietor of the inn, James Jackson, who produced a shotgun and killed Ellsworth. Within seconds, Jackson was taken down by Corp. Francis Brownell, one of Ellsworth's Zouaves. War had arrived. (ALSC.)

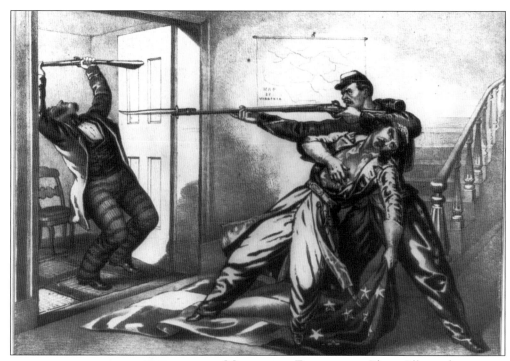

MURDER OF ELLSWORTH. Elmer Ellsworth wrote to his parents, "I am inclined to the opinion that our entrance to the city of Alexandria will be hotly contested. . . . Whatever may happen cherish the consolation that I was engaged in the performance of a sacred duty." Colonel Willcox reported, "Alexandria is ours. . . . I regret to say Col. Ellsworth has been shot by a person in a house." (LOC.)

JAMES JACKSON. According to a friend, ardent secessionist James W. Jackson had "obstinate determination . . . stamped on every feature." A coroner's jury at Alexandria found that Jackson "came to his death at the hands of troops of the United States while in the defense of his private property, in his own house." (ALSC.)

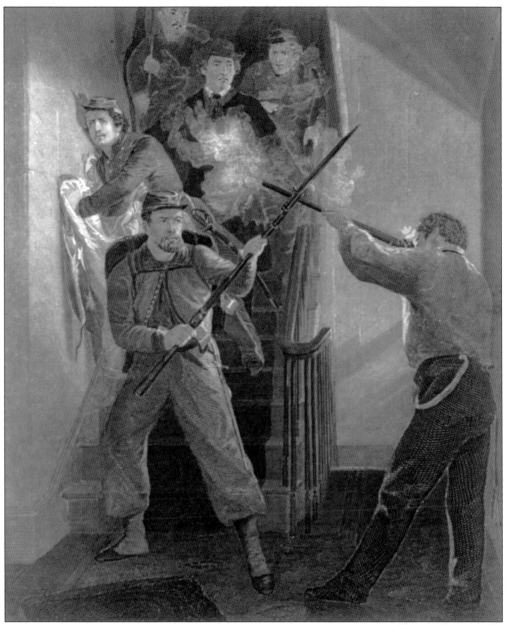

DEATH OF ELLSWORTH. Ellsworth organized a company of Zouaves, troops known for their exotic, Algerian-inspired costumes, that performed at the White House in 1860. A Lincoln election aide, Ellsworth was "like a son" to President Lincoln, who was so greatly upset at the death of the young man that an elaborate funeral was held in the White House. Benjamin Barton, an Alexandria watchmaker, wrote of the federal landing, "It would have been done without blood shed had not Col. Ellsworth too hastily taken down a Southern flag, flying over the Marshall House. . . . James Jackson, the proprietor of the Hotel, met the Colonel on the stairway and in the altercation shot him dead, one of the soldiers accompanying Ellsworth, immediately shot Jackson dead, so two daring men fell at the onset." (LOC.)

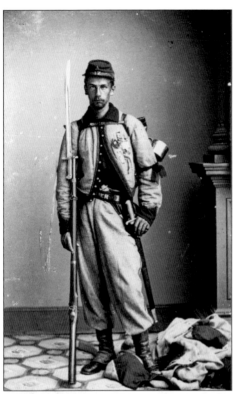

CORP. FRANCIS BROWNELL. Descending the stairs, Ellsworth announced, "Boys, I've got the flag." Jackson emerged from the shadows and said, "Yeah, and I've got you." Jackson shot Ellsworth. In response, Corp. Francis E. Brownell shot Jackson and killed him instantly, pinning Jackson to the wooden stairs with his bayonet for good measure. Zouaves then poured into the hotel, threatening to burn Alexandria to the ground. (ALSC.)

HOME OF JAMES W. JACKSON, FAIRFAX. Sarah Summers saw a carriage coming from Alexandria. A man shouted, "Dismiss your school and go right home. . . . The Union army is advancing!" The women in the carriage were covered in blood. Sarah ran to her grandmother's house, where she found her uncle with the wife and daughter of James W. Jackson and heard their story. (ALSC.)

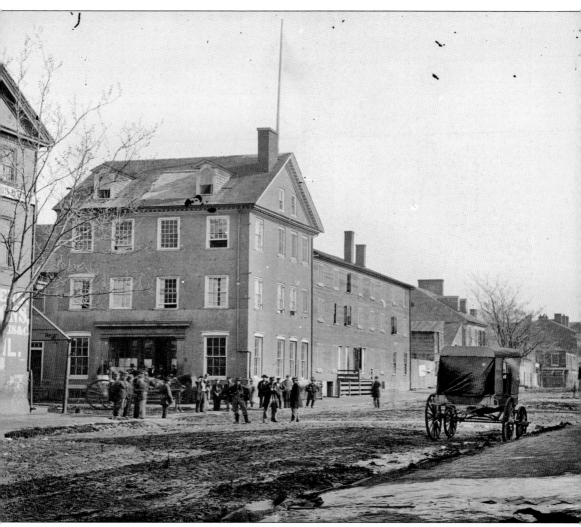

THE MARSHALL HOUSE. Colonel Ellsworth became a cult figure in the North. Sermons, editorials, songs, and poems praised the hero. Babies, streets, and even towns were named after him. Enlistments in the army soared. A New York regiment called Ellsworth's Avengers quickly filled. Corporal Brownell, Ellsworth's true avenger, was lionized and promptly promoted to 2nd lieutenant in the Regular Army. One Ellsworth admirer, Alfred Ballard of the 5th New Jersey Infantry, wrote, "Disembarking, we marched up King St. and halted at the Marshall House where Col. Ellsworth was shot. . . . The stairs on which Ellsworth was shot had been taken away piecemeal. Walls broken, carpets carried off bit by bit, and the flag staff on top of the house from which the Stars and Bars had floated when the Zouaves took possession had been demolished." (LOC.)

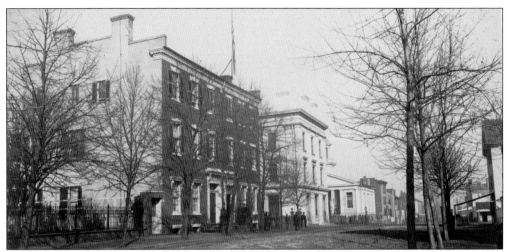

HEADQUARTERS OF GEN. JOHN SLOUGH, MILITARY GOVERNOR OF ALEXANDRIA. General Slough recorded, "When the present Military Governor took command here, there was . . . a 'reign of terror' in Alexandria. The streets were crowded with intoxicated soldiery; murder was of almost hourly occurrence, and disturbances, robbery, and rioting were constant. The sidewalks and docks were covered with drunken men, women, and children, and quiet citizens were afraid to venture." (LOC.)

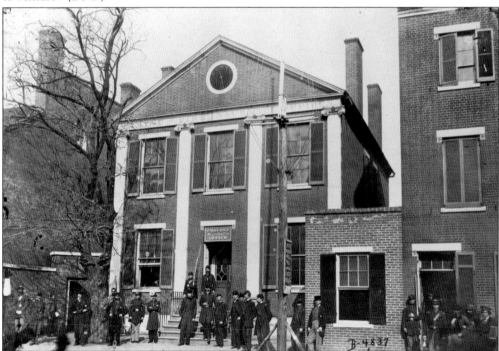

PROVOST MARSHALL'S OFFICE. Alexandria mercantile clerk Henry B. Whittington reported, "Martial law is proclaimed and the Mayor's authority is suspended by a 'Provost Marshall.' Intense excitement prevails at this high handed outrage & there are numbers who were formerly Union Men now denouncing these proceedings . . . and furthermore they proclaim their opposition to this unconstitutional party & promise hereafter a strict adherence to the Southern Confederacy." (ALSC.)

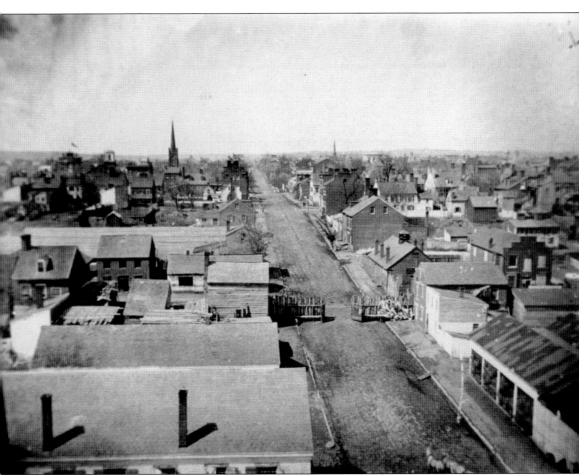

DUKE STREET. The citizens of Alexandria were called upon to sign a loyalty oath renouncing the Confederacy. Most residents refused. This made life in the occupied town difficult. Taking out a business license, being on the street after dark, leaving town, and even buying a cemetery plot required proof that an individual had signed. At one point, those who did not sign were threatened with forcible deportation. Between the Union forts on the outskirts of Alexandria and the Confederate forces, the county was rapidly becoming a no man's land. Much of the news was based on hearsay. Both sides sent out scouting and reconnaissance parties, which made clashes inevitable. One Fairfax Unionist declared that Northern families had been "robbed of nearly everything on earth, so that they are all in absolute want and as things are, no relief can be sent to them, and they have no means of coming away." (ALSC.)

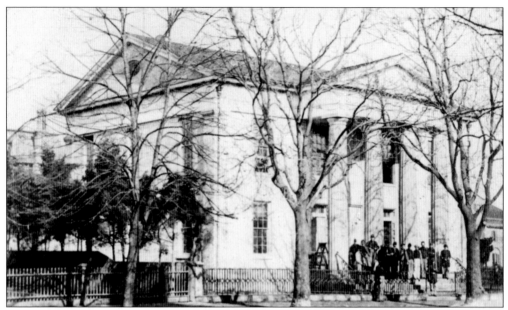

THE LYCEUM. The library, housed in the Lyceum, was closed and the books removed to private homes. The building then became a hospital. According to George Alfred Townsend, "Alexandria is filled with ruined people; they walk as strangers through their ancient streets, and their property is no longer theirs to possess. . . . These things ensued as the natural results of civil war." (ALSC.)

BACK OF THE CITY HOTEL. "Alexandria has been in a dream, but she has awakened to the sad realization of its purity being hourly polluted by the presence of Yankee men and their hired wives. Sooner would we have the cobwebs made by Southern spiders than encounter the hard faces and crude airs of the horde which has infested our town," wrote Melissa Ann Hussey. (ALSC.)

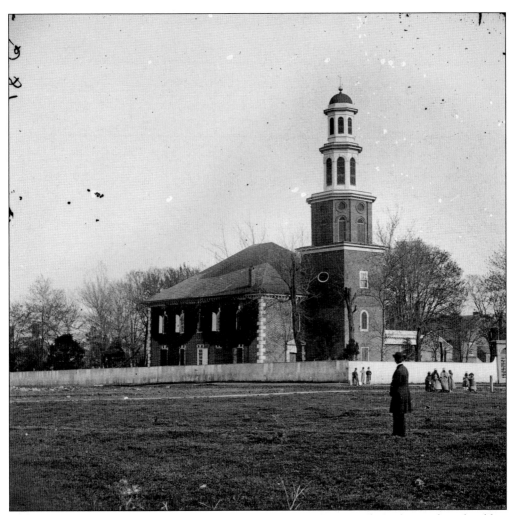

CHRIST CHURCH. During the occupation, many churches were turned into hospitals and stables. Robert E. Lee married George Washington's step-great-granddaughter Mary Custis, whose family attended Christ Church, and prior to the war, he attended services when in the area. Christ Church's reputation as George Washington's place of worship preserved it as a church. Union army chaplains conducted services in the sanctuary, where a Union army congregation grew. Most of the original parishoners worshiped with other Southern sympathizers elsewhere. When the war ended, the church was returned to its parishoners with its interior intact. By the summer of 1863, the *Alexandria Gazette* reported, old residents of Alexandria had mostly departed. "Not one third of the original inhabitants now remain. . . . Many of the old mansions . . . have been deserted by their owners and are now used as barracks or offices of the military authorities." (LOC.)

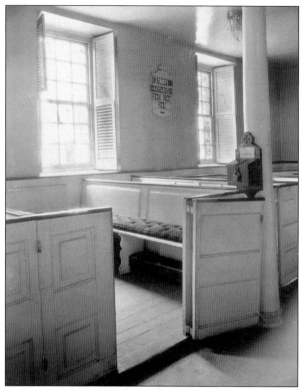

WASHINGTON'S PEW. Union army lieutenant Charles Haydon found Alexandria "a quaint, old looking place. . . . There is not a half hour in the day that I do not have his [George Washington's] presence associated with the surrounding scenery." Lieutenant Haydon mused, "It would do us all good to spend an hour at the grave of Washington in tears over the fate of our country." (ALSC.)

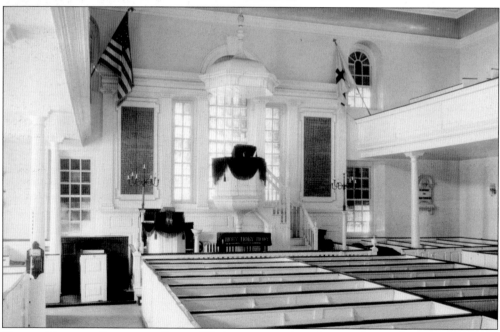

CHRIST CHURCH, INTERIOR. George Washington purchased a pew during the construction of Christ Church and went to services when in Alexandria. His pew is the only one preserved in the original three-sided seating or box configuration. Robert E. Lee attended Christ Church throughout his life, beginning in 1810 when his family moved to the city. (ALSC.)

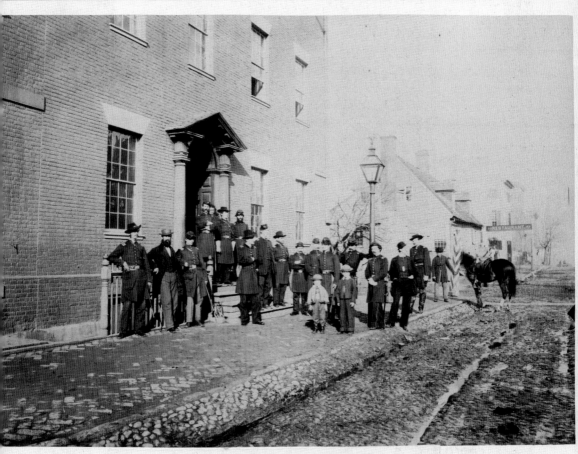

No. 261.—OFFICERS OF FIRST DISTRICT VOLUNTEERS,
City Hotel, Alexandria, Va.

OFFICERS, 1ST DISTRICT VOLUNTEERS. Alexandria businessman Benjamin Barton wrote, "There is a great change in the population, it is more than double in numbers, I meet so many strangers in the street that I feel like being in a strange city, very few of our old inhabitants are to be seen, many have gone away, others have nothing to call them from their homes—many have died; very few of our townsmen are in business now." The wisdom of leaving the county became especially clear when men suspected of sympathizing with the Confederacy were arrested and sent to prison. The Unconditional Union Association of Alexandria, which met weekly, numbered 150 in September 1861. By October it included more than 300 members, and by November over 400, thanks partly to the Union men moving into the area. (LOC.)

29

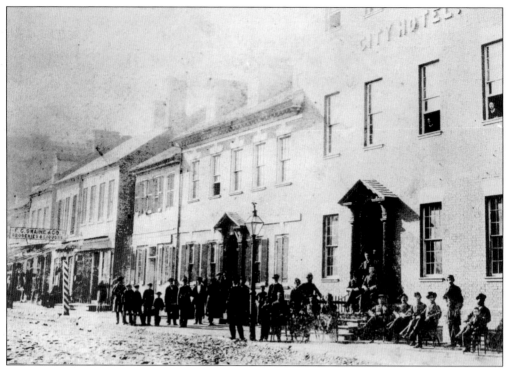

CITY HOTEL, CENTER OF TOWN. "We believe all the stores and shops on King, and the other principal streets of this town are now occupied. . . . At least the stores are frequently cut up and subdivided in such a way as to make three out of one, and we see booths and shanties erected on vacant lots," reported the *Alexandria Gazette*. (ALSC.)

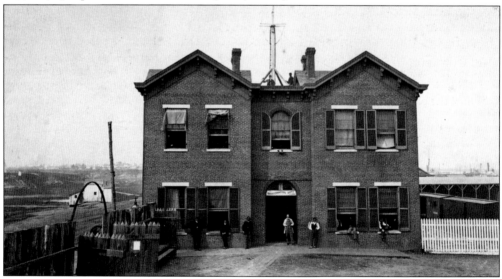

HEADQUARTERS, UNION ARMY COMMISSARIAT. According to an 1862 issue of the *New York Herald*, "The river is obstructed with shipping, the wharves groan beneath the weight of army paraphernalia, long trains of cars slowly creep through the mass of humanity. . . . A dense cloud of dust hangs above all the town, blinding the eyes and choking up the respiratory organs of every visitor to this modern Babel." (LOC.)

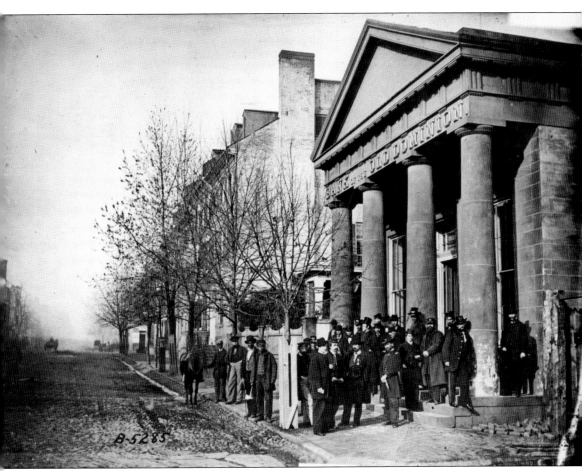

UNION TROOPS AND SYMPATHIZERS AT BANK OF THE OLD DOMINION. Many people were indicted for performing business without a license. To get such a license, the applicant was required to take a loyalty oath. This was loathsome to Confederate sympathizers. An even harsher measure of cracking down on Confederate supporters was the confiscation of property. Civil liberties were a thing of the past. (ALSC.)

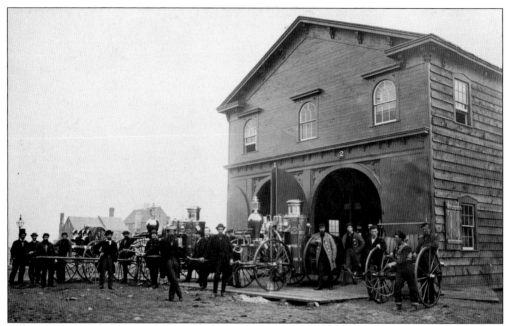

ARMY FIRE DEPARTMENT. In April 1863, the city fire department reported that only two of the four volunteer fire companies were capable of meeting emergencies. Two engines had been destroyed and the companies disbanded. Fortunately, two steam fire engines operated by the Army Quartermaster Department were housed on Princess Street and responded to fire alarms in the city. (LOC.)

415 PRINCE STREET. This address served as the headquarters for Francis Harrison Pierpont, governor of the "restored" state of Virginia, comprising the several northern Virginia counties occupied by Union troops. The capital of the restored state was established in Alexandria for the remainder of the Civil War. (ALSC.)

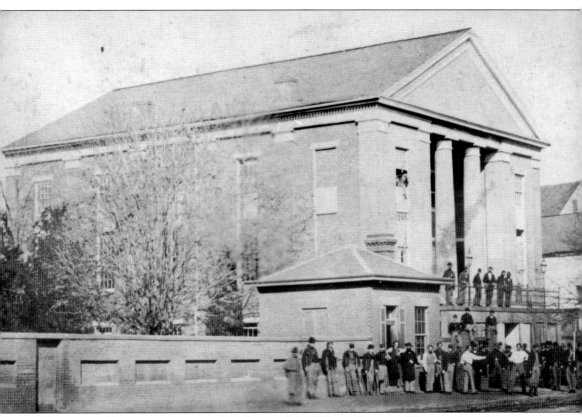

METHODIST EPISCOPAL CHURCH. Northerner Julia Wheelock wrote, "Turning from King into Washington street, we notice a soldier in full uniform with a shouldered musket, pacing to and fro in front of what appeared to be a church. We are told . . . that it is the Southern M. E. Church, but now used as a hospital. . . . We cross the street to the Baptist church, which is also used for a hospital." Medical officers examined men claiming to be sick and then assigned some to cots in the hospital, instructed others to go to quarters, and restored a few to light duty. The less sick and slightly wounded were expected to nurse, clean, and feed the patients and to see to the disposal of bedpans and urinals. In the field, an advance station would be established just beyond musket fire. Stretcher bearers progressed forward to find the wounded. (ALSC.)

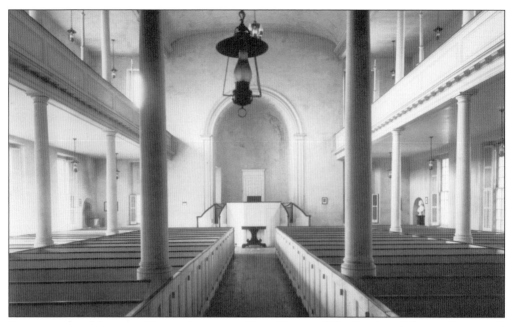

PRESBYTERIAN MEETING HOUSE, INTERIOR. Since Reverend Dr. Harrison did not take an oath of allegiance to the authorities, along with several other local pastors, he was not allowed to perform baptism or marriage ceremonies. As his letters to a friend suggest, he died with a heart grieving over the "evil times" of war and party bitterness. (ALSC.)

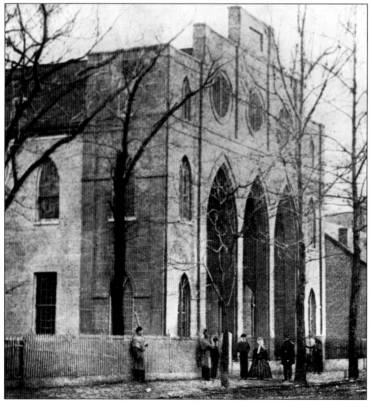

ST. PAUL'S EPISCOPAL CHURCH. Rev. Kinsey J. Stewart omitted the "Prayer for the President of the United States" from the Sunday service. Union soldiers in the church demanded that he show proper respect for the president. Stewart ignored them until he was pulled from the pulpit and marched to jail. The church narrowly escaped burning by enraged Union troops. (ALSC.)

Three

AFRICAN AMERICANS

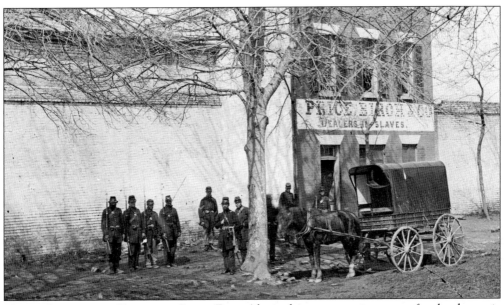

UNION SOLDIERS IN FRONT OF SLAVE PEN. Alexandria was a major center for the domestic slave trade during the antebellum period. Hundreds of thousands of slaves were shipped to the labor-hungry cotton fields of the Deep South. Most citizens accepted slavery as part of the natural order of things. A small group, however, resented its presence. These Virginians spoke up against the harshness and misery inflicted by the traders, who drove slaves through the streets of the city to confinement in "loathsome prisons." The Benevolent Society of Alexandria for Ameliorating and Improving the Condition of the People of Color stated, "These enormous cruelties cannot be practiced among us, without producing a sensible effect upon the morale of the community; for the temptation to participate in so lucrative a traffic, though stained with human blood, is too great to be withstood by all; and even many of those who do not directly participate in it, become so accustomed to its repulsive features, that they cease to discourage it in others." As the number of freed slaves in the city grew, the government instituted a $5 per week reduction in the wages of free black workers to be applied to the support of the former slaves. (LOC.)

OH CARRY ME BACK

TO OLE VIRGINNY.

Entered in Clerks Office Southern Dist. New York Nov 23. 1859.

Oh carry me back to ole Virginny. This label does not refer to the famous song by James A. Bland (1854-1911), because it was published when the composer was only 5 years old. It refers to an earlier song by the same name. The label shows a Negro family entertaining each other in their cabin. The father plays the banjo while the mother teaches her small son to dance. Two additional children are watching the father perform. Genre piece with sentimental flavor. 1859. Black and white lithograph on beige background.

This label is based on an oil painting by Eastman Johnson (1824-1906)

Old Kentucky Home, life in the South, 1859. It was shown at the National Academy in 1859 under the title

CARRY ME BACK. Thousands of slaves fled their owners. The two main causes for running were the desire to escape being sold into the Deep South and the desire to reunite with family members. Virginia soon became the single largest source of slave labor. (LOC.)

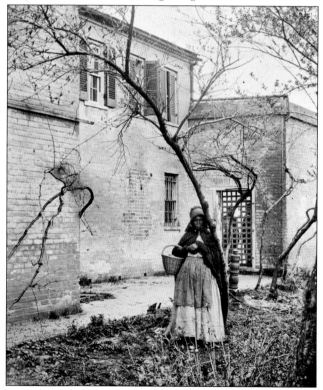

DUKE STREET SLAVE PEN. In 1844, G. W. Feathersonhaugh wrote, "There was much method and vigilance observed for [the slaves], always watchful to obtain their liberty, often show a disposition to mutiny, knowing that if one or two of them could wrench their manacles off, they could soon free the rest, and either disperse themselves or overpower and slay their sordid keepers." (LOC.)

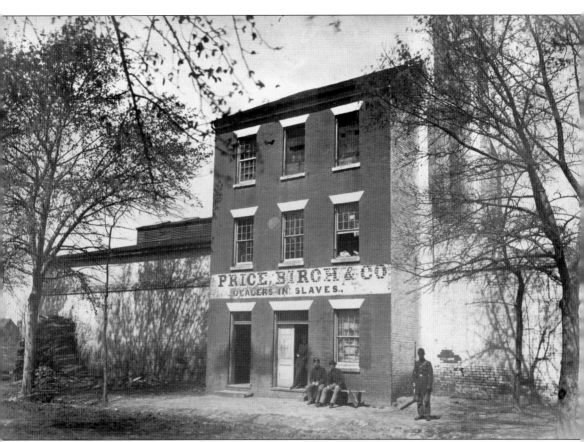

FRONT OF THE SLAVE PEN. Slaves being sold to cotton planters farther south were brought into Alexandria from the countryside and housed in the pen until the time for sale. Following sale, they were herded to the Alexandria wharves and shipped out in lots by steamboat. Lewis Bailey, taken from his family and sold as a young boy, walked back to Alexandria from Texas after the Civil War to reunite with his mother. Masters were forced to explain why content and well-cared-for servants ran away so frequently and in such large numbers. Many owners concluded that frequent runaways were mentally imbalanced. Masters devoted considerable energy to controlling the movement of slaves. Written passes were needed to leave the plantation. Overseers watched the quarters, patrols were formed, professional slave hunters were employed, and rewards were offered. (LOC.)

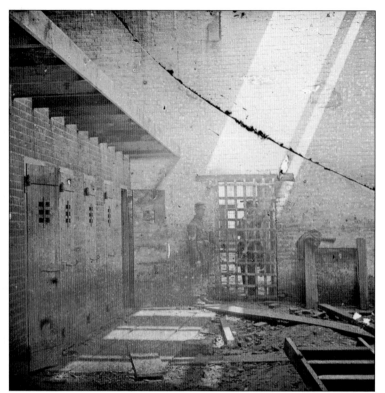

INSIDE THE SLAVE PEN. An 1846 newspaper advertisement read, "We wish to purchase likely young negroes, between the ages of 12 and 30 years. We do not intend to insult the understanding of sensible men by any contemptible boasting, and therefore, content ourselves with a publication of the simple fact that we are anxious to buy negroes of both sexes, of the above description, at liberal prices." (LOC.)

SLAVE PEN. "Turning to the left, we came to a strong grated door of iron opening into a spacious yard. . . . The gate was secured by strong padlocks and bolts, but before entering we had a full view of the yard . . . through the grated door," recalled Ethan Allen Andrews in 1835. (LOC.)

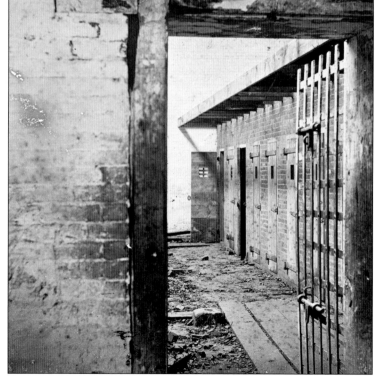

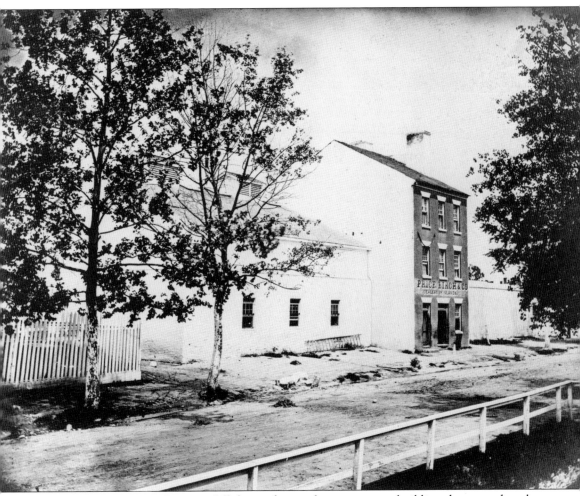

SLAVE PEN ON DUKE STREET. Off the yard was a long, two-story building that served as the slaves' sleeping quarters. Ethan Allen Andrews wrote in 1835, "Their blankets were then lying in the sun at the doors and windows which were grated like those of ordinary prisons." At night the slaves were often chained "lest they should overpower their master, as not more than three or four white men frequently have charge of a hundred and fifty slaves." Among the primary causes for running away was a desire to reunite with family. The separation of family members was commonplace after 1820. In the Upper South, sale ended one-third of slave marriages and separated one-third of children under 15 from their parents. Destinations for runaways were often dictated by an expectation of finding loved ones. (LOC.)

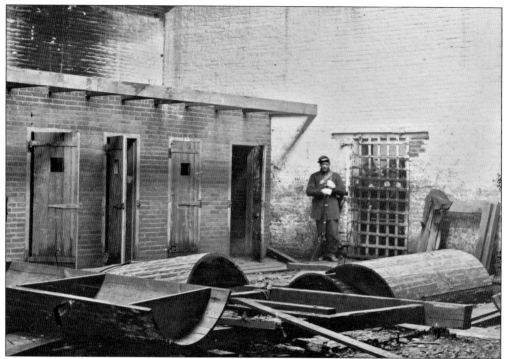

SLAVE PEN IN DISARRAY. Slave trader George Kephart went out of business abruptly on May 24, 1861, as the Union army marched into Alexandria. When federal troops arrived at the pen on Duke Street, it was in complete disarray, the sole occupant one old slave still chained to the floor. (LOC.)

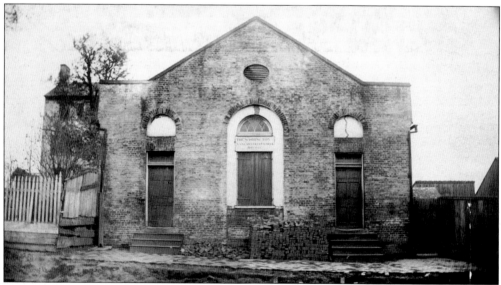

LANCASTRIAN SCHOOL. The Lancastrian method of teaching allowed older students to drill younger students under the overall supervision of one adult. This system could accommodate more students. African American children were taught here until the 1847 retrocession of Alexandria to Virginia, after which black children were prohibited by law from receiving an education. During the occupation, Union troops held classes for black children. (ALSC.)

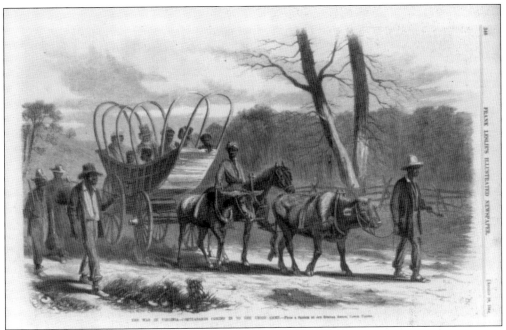

CONTRABAND COMING INTO THE UNION CAMP. In April 1862, President Lincoln emancipated all slaves in the District of Columbia and nine months later issued the Emancipation Proclamation. Many blacks from nearby states sought refuge in Alexandria. Those who came under Union control were known as contraband. Slaves escaping to Union lines were "contraband of war" and would not be returned to their masters. (LOC.)

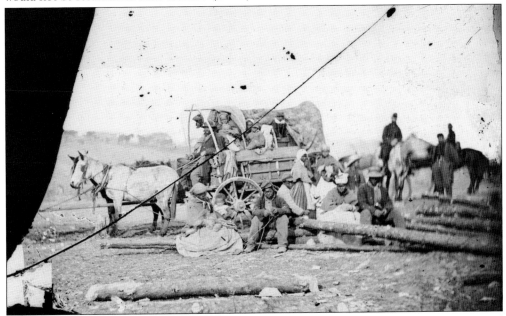

ARRIVAL OF FAMILY IN THE LINES. Thousands of freed slaves looked for safe harbor around Alexandria. Often they found horrible living conditions, sickness, disease, and death. In 1864, the military governor of Alexandria seized the pasture of a Confederate sympathizer and established a burying ground for the freedmen. Some 1,700 freed people were buried here. (LOC.)

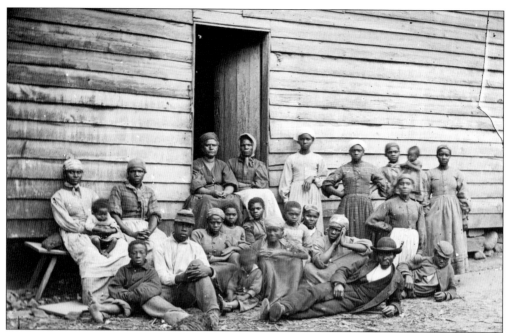

FREED SLAVES. The federal government was the main employer of Alexandria's free blacks and freed slaves. Many worked for the U.S. Military Railroad and as stevedores on the government docks for the Office of Commissary Subsistence, which distributed food, coal, and hay. (LOC.)

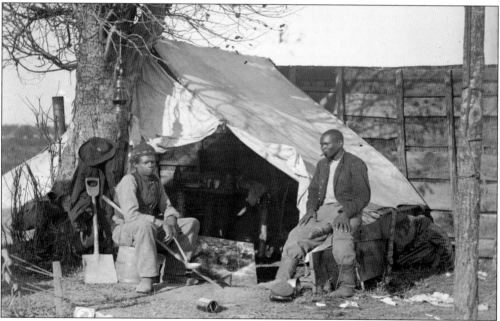

FORMER SLAVES WHO FLED TO UNION LINES. Blacks were a novelty to many Northerners who had never seen an African American before reaching Virginia. By 1864, the contraband population had grown to 7,000. Alexandria provided just what they needed, according to the *Alexandria Gazette*: protection, plenty of work at a fair price, and punctual payment. Only 25 names were on the charitable ration list. (LOC.)

Four

RAILROADS

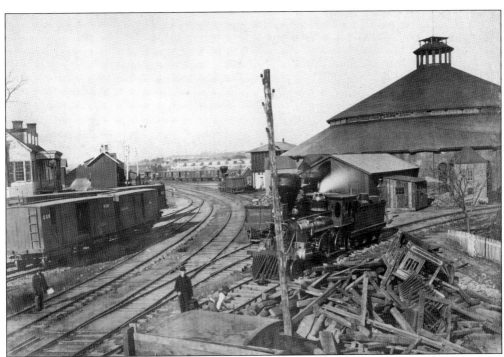

LOCOMOTIVE AND ROUNDHOUSE. Since the dawn of history, military strategy has been dominated by logistics. According to an old saying, "Amateurs study tactics; professionals study logistics." Obviously, a railroad train could carry more tons of cargo than a mule-drawn wagon. A Civil War–era freight locomotive could travel only 35 miles or so on a ton of fuel, but its payload could be as high as 150 tons. Brig. Gen. Herman Haupt, a railroad construction engineer, revolutionized military transportation during this time. On the opposite side, Confederate raider John S. Mosby, the "Grey Ghost," immobilized 30,000 Union troops by his daring lightning raids. (LOC.)

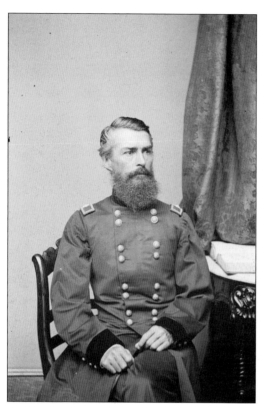

BRIG. GEN. HERMAN HAUPT. Haupt's efficient trains helped supply the Union army and carried thousands of wounded soldiers to hospitals. (LOC.)

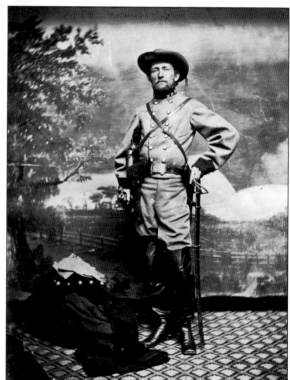

COL. JOHN S. MOSBY. Confederate raider John S. Mosby destroyed railway tracks, robbed Union paymasters, captured pickets, and shot down stragglers. (LOC.)

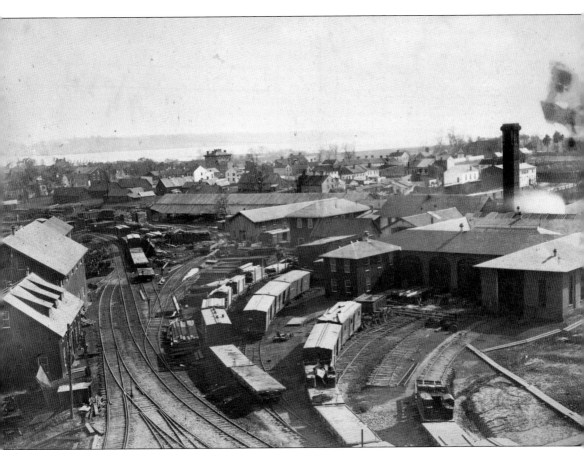

BIRD'S-EYE VIEW OF RAILROAD MACHINE SHOPS. The Union army immediately took control of the railroads in Alexandria. The city was a significant hub, with a railroad machine shop already in operation. Isaac Entwistle and William S. Moore were the proprietors of a large manufactory that produced boilers, mill gearing, steam engines, iron fencing, and other railroad equipment. Thomas Jamieson's plant, advertised as "fitted up with every facility and convenience for working in metals," produced railroad cars, as did factory proprietor John Summers. The Union army geared up existing facilities for the exigencies of war. Sidings were built to the warehouses and wharves. In February 1862, the first rail connection between Alexandria and Washington was completed. Some 50,000 railroad cars were hauled over this seven-mile line during the course of the war. (LOC.)

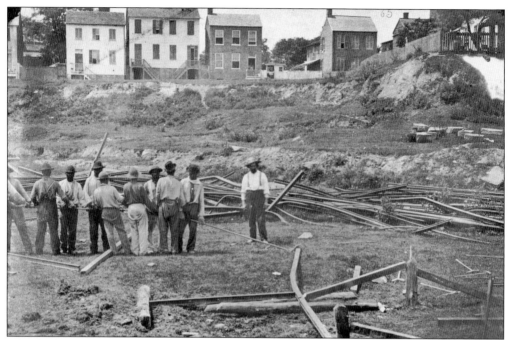

RAILROAD WORKERS STRAIGHTENING TRACK. A single stretch of the Orange and Alexandria Railroad connected the Union army to the vast supply depots of Alexandria and Washington. At various times during the war, the Confederate army cut telegraph lines, tore up rail lines, and destroyed railway bridges in northern Virginia. The enormous task of keeping the trains running was essential for victory. (LOC.)

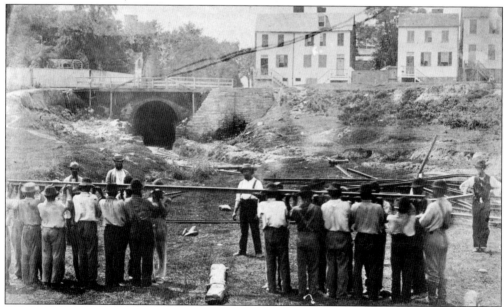

WORKERS HOLDING TRACK. General Haupt first sent out wrecking crews and a construction train to repair damaged tracks and bridges. Behind this were supplies and rations for the army, heavily guarded with riflemen sitting on top of the railroad cars. Haupt arranged to send surgeons to the front, bring back the wounded, and transport 1,000 volunteer nurses. (LOC.)

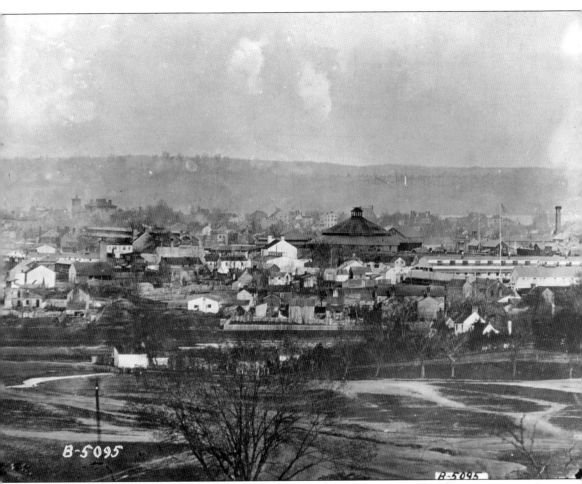

B-5095

B-5095

ROUNDHOUSE. Railroads in the 1860s were small-scale local enterprises. The Union army wanted priority treatment, but railroad managers still had an obligation to maintain civilian traffic and make money. In January 1862, Congress authorized President Lincoln to seize control of the railroads and telegraph for military use. Operations were turned over to the new war department agency called the U.S. Military Rail Roads (USMRR). Herman Haupt, once the chief engineer of the Pennsylvania Railroad, became chief of construction and transportation in the Virginia theater. He also attained the rank of brigadier general. Haupt's Construction Corps, which emphasized speed rather than permanence, employed many free blacks and former slaves. The Union army's heavy reliance on railroads greatly reduced the element of strategic surprise in Virginia. (ALSC.)

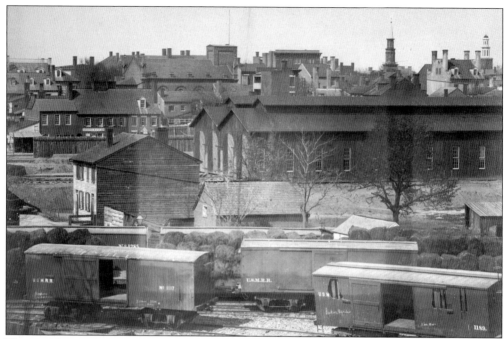

VIEW OF ALEXANDRIA SHOWING NEW ENGINE HOUSE. When defeated, the rail-supplied Union army was often reinforced before its Confederate enemies could exploit success. Confederate tactical victories seldom led to strategic gains. After the First Battle of Manassas, when McDowell's defeated army retreated to Alexandria and Washington, it fell back on its replenishing railheads. (LOC.)

ARMY SUPPLY WAGONS. Trains traveled five times faster than mule-drawn wagons and reduced the number of required supply vehicles. Faster travel meant cargoes arrived at the front in better condition. Troops traveling by train experienced less fatigue. Railroads boosted logistical output by at least a factor of 10, profoundly impacting the outcome of the Civil War. (LOC.)

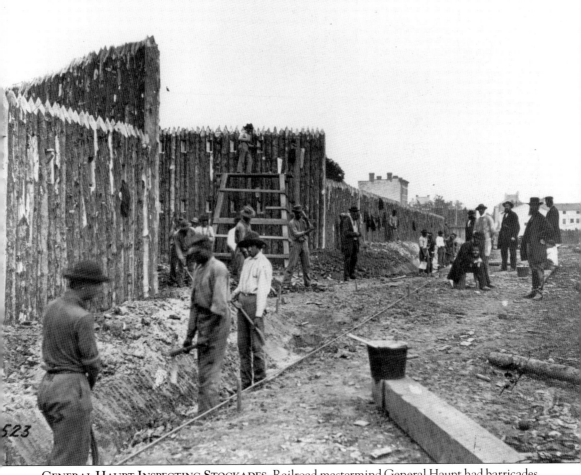

GENERAL HAUPT INSPECTING STOCKADES. Railroad mastermind General Haupt had barricades erected across the streets leading to the wharves to protect army supplies from rebel cavalry raids. The Union supply depot was a high-value target. The entire 12-block area around Duke Street occupied by the U.S. Military Railroad system was also enclosed by a stockade. The Confederates never raided Alexandria, but the disruption of supply lines and the constant disappearance of couriers frustrated Union commanders to such a degree that General Grant ordered, "When any of Mosby's men are caught, hang them without trial." On September 22, 1864, Union forces executed six of these men. Mosby ordered seven Union prisoners, chosen by lot, to be executed in retaliation. Mosby then requested that commanders resume treating prisoners with humanity. The Union side agreed, and there were no more executions. (ALSC.)

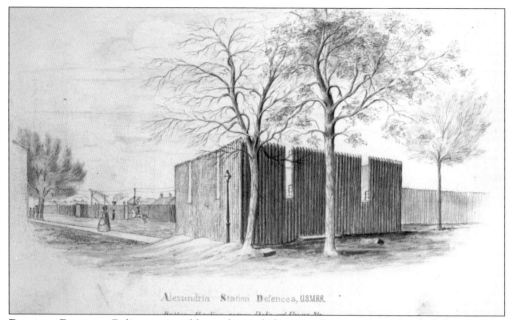

BATTERY BASTION. Reliance on rail lines channeled major advances along clearly defined routes. During the first three years of the war, the Confederacy could easily predict where Union advances would occur. In addition to major offensives, smaller-scale raids against railroads were a common practice by both sides. (ALSC.)

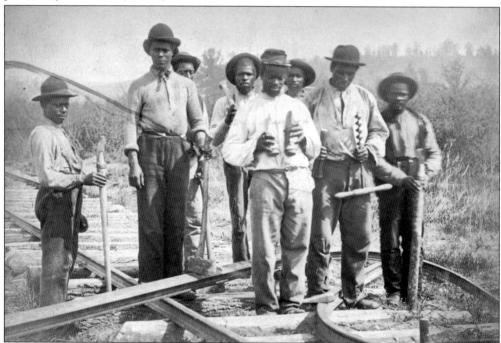

RAILROAD WORKERS. During the Civil War, railroads were still a novelty for the military. When Union general John Pope needed critical supplies in August 1862, packed boxcars were sitting in Washington. The supplies could not be moved across the Potomac River because authorities were afraid that available locomotives were too heavy for the rickety railroad bridge. (LOC.)

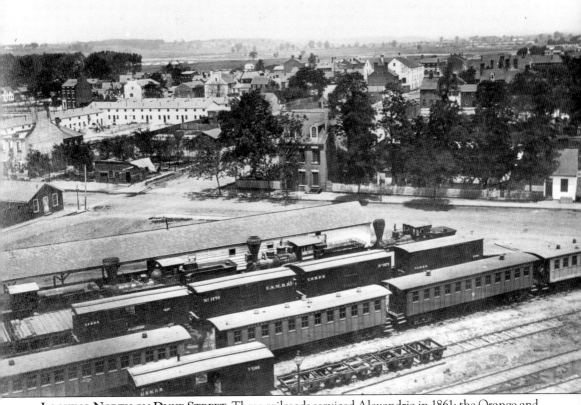

LOOKING NORTH ON DUKE STREET. Three railroads serviced Alexandria in 1861: the Orange and Alexandria, running south to Lynchburg; the Alexandria, Loudon, and Hampshire, running west to Leesburg; and the Manassas Gap, running from the Valley of Virginia to Manassas Junction and then into Alexandria over the tracks of the Alexandria and Orange. The Richmond, Fredericksburg, and Potomac Railroad operated steamships between Aquia Creek and Alexandria. The railroads had a major economic, industrial, and commercial impact on Alexandria even before the war. In 1859, the city received 91,000 bushels of wheat from rural Virginia destined for shipment to other ports, making it the second largest wheat exporting center in Virginia. At the same time that freight cars were bringing agricultural products into Alexandria for shipment, trains laden with guano fertilizer from South America moved inland from the city. This imported fertilizer was the key to a resurgence of agricultural exports in Virginia. (ALSC.)

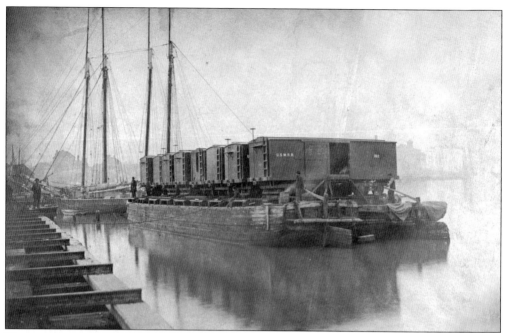

TRANSPORTATION ON THE POTOMAC. Early in the war, Northern railroad executives were more concerned with profits than patriotism. They continuously haggled with army officers. Corruption in the industry prompted the enactment of the Railways and Telegraph Act in 1862, allowing the government to seize railroads to preserve public safety. (LOC.)

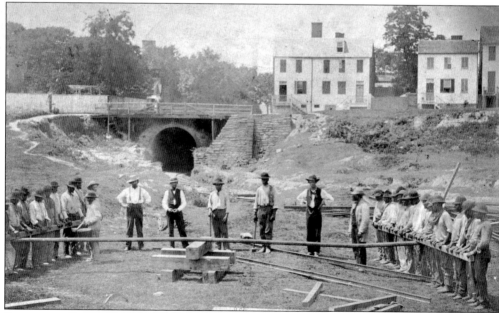

RAILROAD CONSTRUCTION WORKERS. General Haupt recruited an assortment of frontier woodsmen, skilled craftsmen, and freed slaves to create a railroad construction corps. One of his first notable achievements was the reconstruction of the bridge over Potomac Creek. The original bridge had taken three years to complete. Haupt and his men built the 300-foot-long and 100-foot-tall trestle in less than a week. (LOC.)

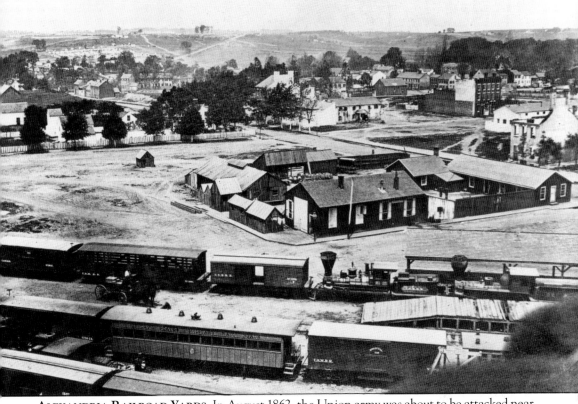

ALEXANDRIA RAILROAD YARDS. In August 1862, the Union army was about to be attacked near Manassas. Union reinforcements jammed into Alexandria and waited for train transport. Herman Haupt performed miracles in rushing troops forward and evacuating supplies threatened with capture. One commander bringing up reinforcements stopped four trains on the main line near Alexandria and ordered them to transport his brigade to the front immediately. This irresponsible action completely disrupted Haupt's work. The Union military railroad system suffered from micromanagement by the secretary of war, overlapping authority among major players, military districts that operated autonomously, and railroad officials who tended to deal directly with local military authorities rather than central command. In many ways, this was organized chaos. Despite its flaws, the Union system succeeded in making the trains run. (ALSC.)

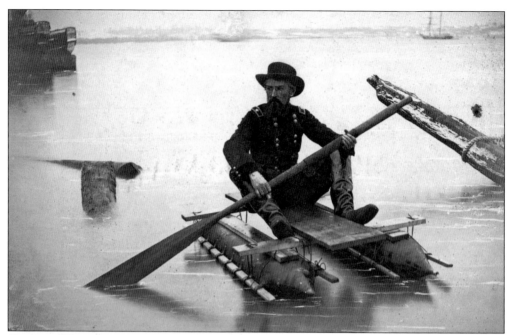

GENERAL HAUPT INSPECTING RAILS ALONG THE RIVER. Haupt began by demanding that he should have no rank, title, or uniform and no compensation beyond his expenses. He maintained that he could go back to his Western Massachusetts railroad tunnel after the campaign ended. He recruited his own labor force, built railroads and bridges furiously, and told military officers to go to hell. (LOC.)

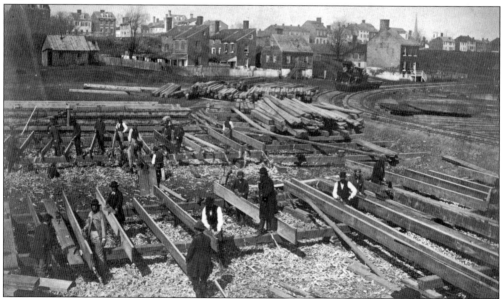

TRACK NEAR THE POTOMAC RIVER. When General Burnside moved down the Rappahannock River as a prelude to an advance on Richmond, Herman Haupt changed the army's main supply line from the Orange and Alexandria Railroad to one using a combination of water and rail transit. He sent construction crews to Aquia Landing to repair the wharf and fixed the Richmond, Fredericksburg, and Potomac lines. (LOC.)

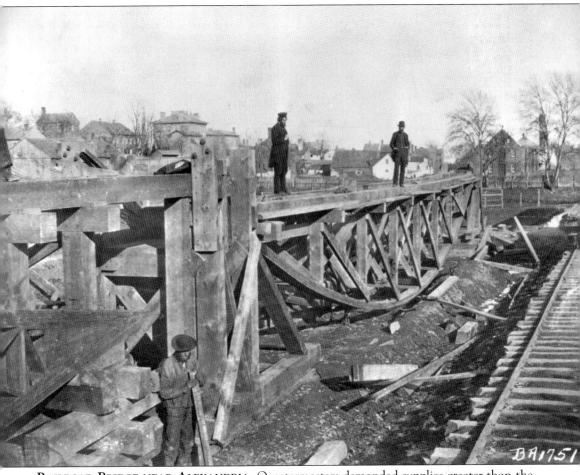

RAILROAD BRIDGE NEAR ALEXANDRIA. Quartermasters demanded supplies greater than the actual requirements of troops and insisted on rail transportation to evacuate these supplies when threatened by enemy capture. Line officers commandeered trains for their units, snarling traffic. Some officers seized railroad cars for their own use. Confederates forces, both regular and irregular, found these lines to be rich targets for sabotage and plunder. Herman Haupt's rules were simple: no military officers would interfere with the running of trains; supplies went forward only as required; trains at the front unloaded immediately; trains would run on rigid schedules; and on lines where opposing trains could not pass each other, convoys of five or six trains would travel as a group. Each convoy delivered its cargo and returned to base before the next convoy started out. (ALSC.)

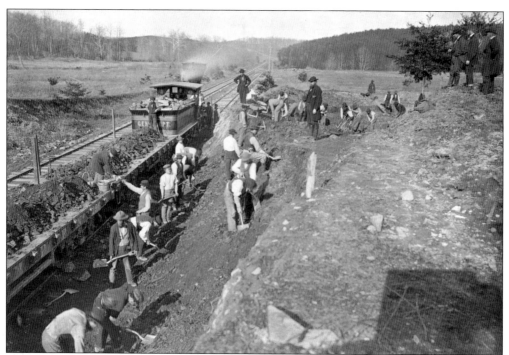

WORK ON DEVEREUX STATION. Wood was cut and stacked along the track at frequent intervals. Water tanks appeared sometimes only five miles apart. Whenever possible, the tanks were established near springs or streams, as railroaders deemed clean water very important for their locomotives. Soldiers along the line were prohibited from bathing in the railroad water tanks (because soapy water would foam up in the locomotive boilers). (LOC.)

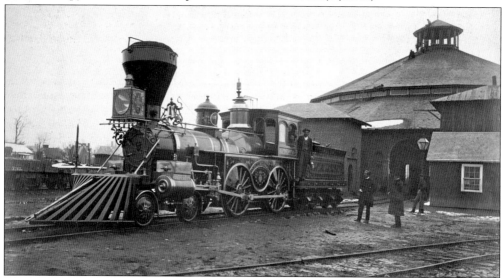

ENGINE J. H. DEVEREUX. The advantage of the "American" steam locomotive was its ability to negotiate sharp curves and irregular track without derailing. The large driving wheels, powered via connections to steam-powered pistons, were usually four to five inches in diameter, with large drivers intended for passenger service and smaller drivers for freight service, although many engines were used interchangeably. (LOC.)

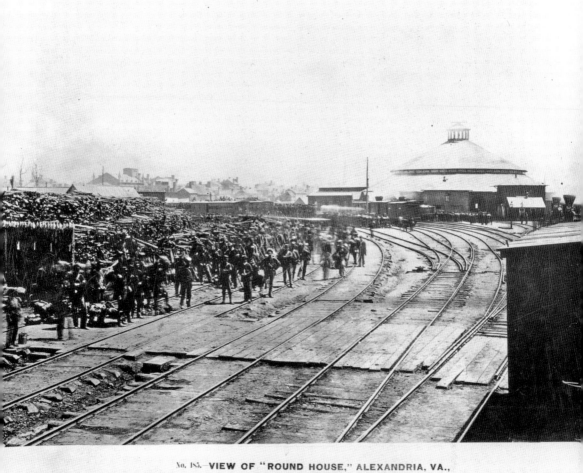

No. 185. **VIEW OF "ROUND HOUSE," ALEXANDRIA, VA.,**
Orange & Alexandria Railroad

ROUNDHOUSE AND RAILROAD YARD. Ideally, a tactical military rail line would have numerous sidings to allow opposing trains to pass, spacious platforms to facilitate unloading, a place for turning, and a telegraph system to coordinate train movements. Railroads near the front lacked most of these elements. Additional problems included tracks that were in bad condition and destroyed bridges. Officers who knew nothing about railroad operations could cause even more serious issues. General Haupt's finest hour came in 1863 during the Gettysburg campaign. Construction teams replaced bridges and repaired track torn up by Confederate raiders. Transportation crews brought in locomotives and cars from the lines in Virginia. Haupt was able to maintain virtually continuous rail support for the Union army throughout the campaign of maneuver. This was essential to the final victory. (ALSC.)

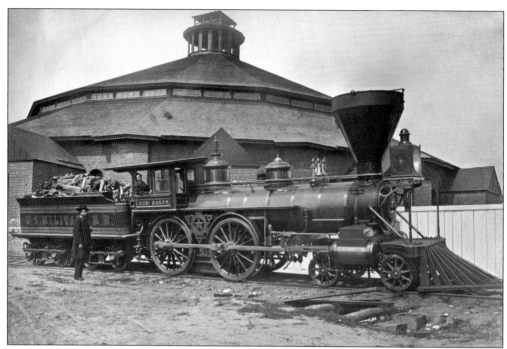

ENGINE GENERAL HAUPT. Few military men had experience with railroad transportation; the true experts were the civilian executives who managed railroads. These civilians were commissioned as officers and placed in positions of authority. Despite many flaws, the system worked. (LOC.)

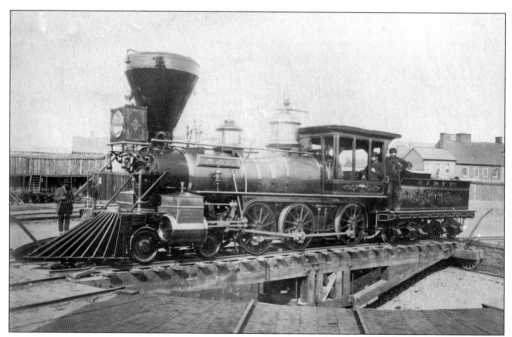

ENGINE E. M. STANTON. The steam locomotive made possible the extensive railroad network that developed in the 1850s. Consuming vast quantities of wood and water, these early engines provided the power to transport people and supplies throughout the war. (LOC.)

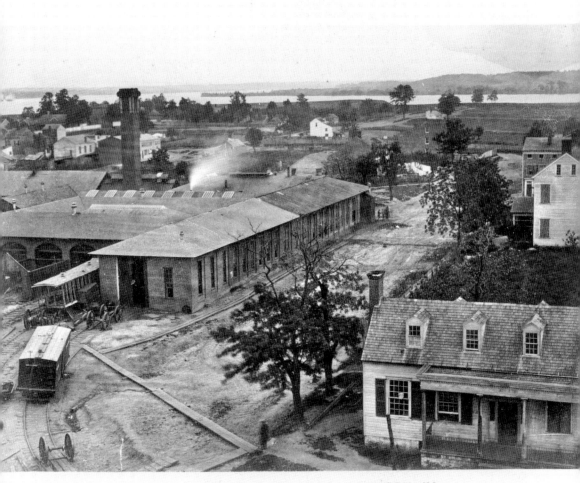

No. 10.—U. S. M. R. R. MACHINE SHOPS, ALEXANDRIA, VA.,
March, 1863.

VIEW OF U.S. MILITARY RAILROAD MACHINE SHOPS. Although the size and tempo of railroad operations greatly increased during the war years, even before the war Alexandria was home to the Smith and Perkins Locomotive Works. The company manufactured engines for the Manassas Gap, Baltimore and Ohio, and Hudson Valley Railroads. Smith and Perkins employed some 200 skilled industrial workers. Alexandria was also home to other industries such as machine shops and foundries. Later in the war, freight cars were built in the city for use by the Union army in the western theater of operations. In the spring of 1865, a private railroad car was constructed in Alexandria for President Lincoln's personal use. Ironically, this special presidential car was employed for the first time as a funeral car to transport the slain Lincoln to his home in Springfield, Illinois. (ALSC.)

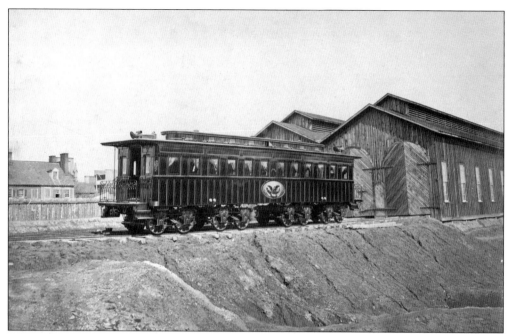

THE PRESIDENT'S CAR. Lincoln's funeral train left Washington on April 21, 1865, and retraced much of the route Lincoln had traveled as president-elect in 1861. The nine-car Lincoln Special, whose engine displayed Lincoln's photograph over the cowcatcher, carried approximately 300 mourners. Depending on conditions, the train usually traveled between 5 and 20 miles per hour. (LOC.)

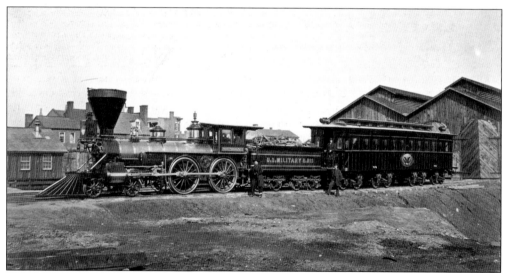

ENGINE W. H. WHITON AND THE PRESIDENT'S CAR. The locomotive's distinctive balloon stack was intended to control sparks from the burning wood fuel. A cab offered protection for the engineer and fireman. Most locomotives of this period had cowcatchers to minimize damage should the train encounter livestock on the tracks. Each engine had a tender, which carried wood, fuel, and water. (LOC.)

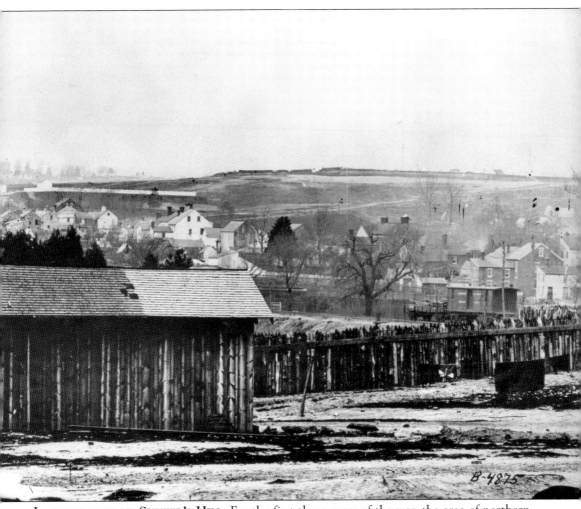

LOOKING TOWARD SHUTER'S HILL. For the first three years of the war, the area of northern Virginia just beyond the city of Alexandria was a genuine no man's land, with rival cavalries and sympathizers skirmishing and sniping at one another. The Confederate government formally recognized irregular "partisan rangers" as an integral part of its armed forces. The Union regarded such fighters as little better than pirates since they were permitted to keep anything they could capture from federal troops. Commanders sometimes sent locomotives to reconnoiter the terrain and gain information on enemy troop dispositions. A lone locomotive could quickly reverse direction and move as fast as 60 miles per hour, far faster than pursuing cavalry. Locomotives were also useful as courier vehicles—an important advantage when Confederate raiders such as John Singleton Mosby and his men cut telegraph lines. (ALSC.)

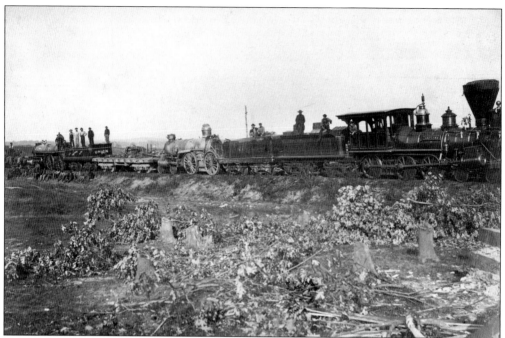

REMAINS OF A WRECK. Colonel Mosby's raiders were a constant danger to the railroads. In October 1864, the Union army forced a number of Alexandria's prominent citizens known to be Confederate sympathizers to ride military trains as hostages to prevent attacks. Edgar Snowden Jr., editor of the *Alexandria Gazette*, was one. The *Gazette* was consequently forced to suspend publication from October 13, 1864, to January 3, 1865. (LOC.)

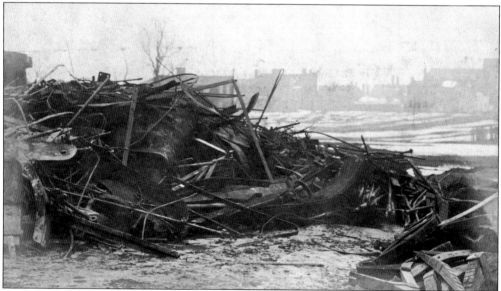

RAILROAD SCRAP HEAP. Explosive devices planted in the roadbed posed serious threats to trains. Mines were often artillery shells with percussion fuses. Buried in the roadbed, they would be detonated by a passing train. Mines, especially those using artillery shells, could lift locomotives off the tracks. Some federal commanders threatened to deport local inhabitants or destroy their farms if explosions occurred on rail lines. (LOC.)

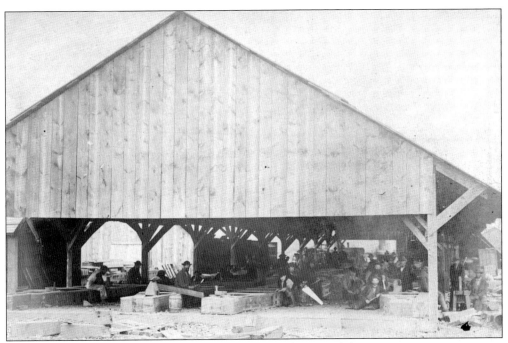

SHED AT CARPENTER SHOP. Union officers armored some of their engines against snipers. Unfortunately, train crews found that armor limited their ability to escape from the engine in case of emergencies—an important consideration, since a ruptured boiler could fatally scald a crew. Armor was eventually applied only to some parts of the cab. (LOC.)

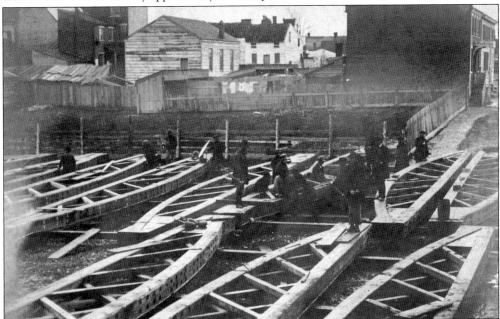

PORTABLE BRIDGES. The Construction Corps was responsible for making rail lines fit for military use. The group consisted of professional civil engineers, skilled workmen, and manual laborers who were provided with materials, tools, and their own transport. Among their materials were prefabricated tracks and bridges to quickly replace those destroyed at the front or by raiders. (LOC.)

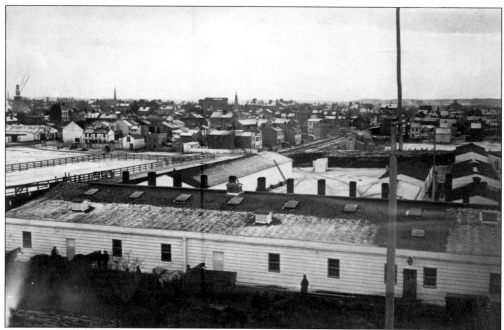

GOVERNMENT BAKERY. To provide bread for the troops, the Union army built an enormous bakery covering the northeast block of Princess and Fayette Streets. Some 200 employees worked 20 ovens and produced about 90,000 loaves of bread a day. In February 1863, the bakery set a record for production in a single day, making some 114,550 twenty-ounce rations. (LOC.)

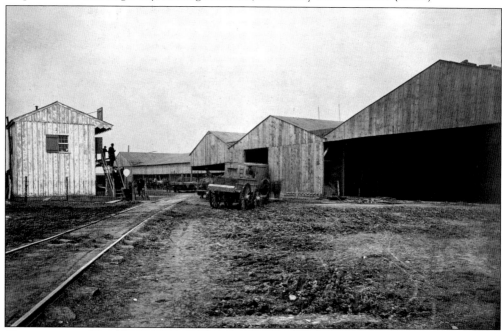

GOVERNMENT HAY BARN. Animal logistics were an important consideration for military planners. A horse required 14 pounds of hay and 12 pounds of grain per day, a mule the same amount of hay but only 9 pounds of grain. An army of 50,000 men consumed over 1,000 cattle per month. (LOC.)

Five

THE RIVER

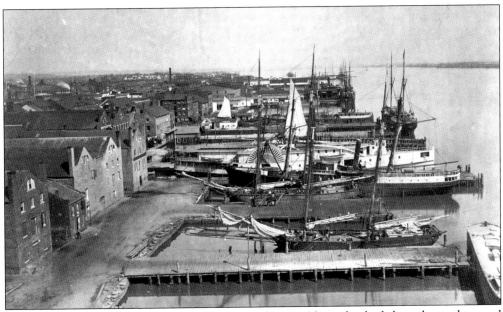

THE PORT OF ALEXANDRIA. From earliest Colonial times, Alexandria had always been a busy and bustling port. As relations between North and South deteriorated, the Northern press accused Virginians of stopping small ships headed for Washington. The *Alexandria Gazette* claimed that federal authorities were seizing ships bound for Alexandria and interfering with Virginia trade. At the outbreak of war, Confederate gun batteries on the Potomac River stopped Union vessels from reaching Washington. This blockade ended in early 1862 as the Confederate army retreated southward. The Confederacy's new ironclad Virginia provided fresh (if short-lived) worries, as federal officials expected an attack up the Potomac River. After the federal occupation, Alexandria businessman Benjamin Barton noted that "the great number of steamboats, sloops, schooners and brigs required, arriving at this port, and passing up to Washington, has the appearance of a fleet opposite our City." (LOC.)

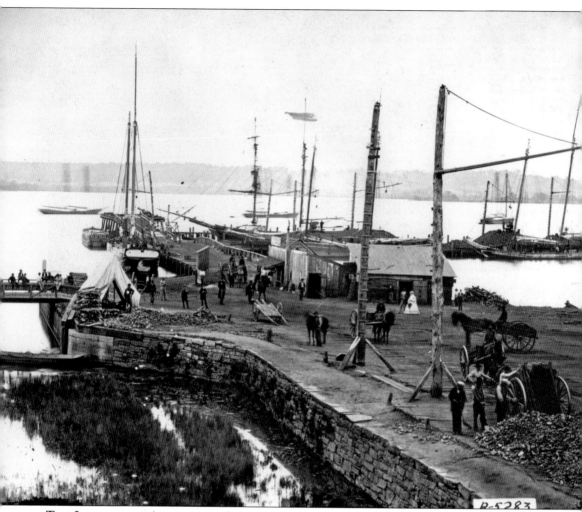

TIDE LOCK OF THE ALEXANDRIA CANAL. Congress granted a charter to the Alexandria Canal Company on May 26, 1830. When completed, the canal crossed the Potomac River in an aqueduct bridge more than 1,000 feet long between Georgetown and Rosslyn, then ran on level ground seven miles to the edge of Alexandria, terminating in a large basin. Typical products shipped by canal to Alexandria were wheat, corn, whiskey, cornmeal, and flour; those transported from Alexandria by canal included fish, salt, plaster, and lumber. The Alexandria Canal was a calamitous financial failure for the city. The goal was to join the Potomac and Ohio Rivers, thus opening up western markets. The Alexandria Canal Company never fulfilled the dreams of its founders. The rapid development of railroads and steamships made the canal slow and antiquated by comparison. (ALSC.)

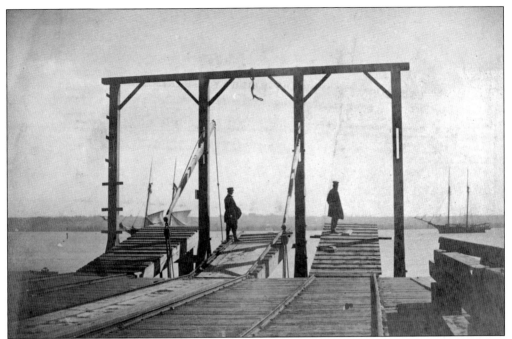

BRIDGES TO WAITING BARGES. Freight cars coming into Alexandra and destined for troops in the field were loaded onto barges at the railroad wharf. The barges were towed down the Potomac River to Aquia Creek, where the railroad cars were unloaded onto the tracks of the Richmond, Fredericksburg, and Potomac Railroad. Two barges bolted together could carry 16 cars. (LOC.)

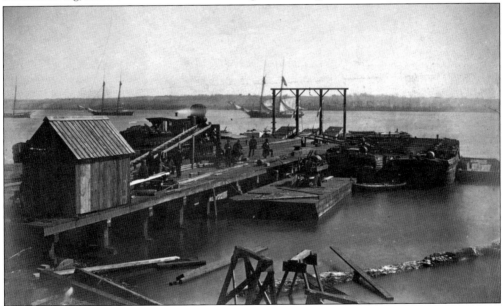

THE WHARF AT ALEXANDRIA. The wharf was bustling with military traffic. A soldier of the 40th New York Infantry wrote, "It is quite impossible to conceive of the immense quantities of supplies piled on the docks. . . . Thousands of barrels of beef and pork, and many more thousand boxes of hard tack were stacked in immense piles, tier upon tier, higher than the surrounding buildings." (LOC.)

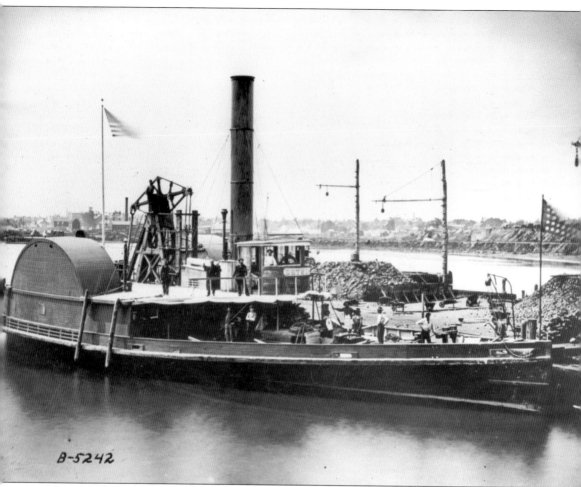

B-5242

UNION SIDEWHEELER STEAMSHIP AT THE ALEXANDRIA WHARF. The *Philadelphia Inquirer* reported in 1863, "This ancient city has now become . . . the great warehouse . . . for the supplies of the Army of the Potomac. Miniature mountains of hay and pyramids of oat bags, high up in the air, meet the gaze as one approaches the city from the river. . . . The wharves are filled with all kinds of stores for the use of our brave army." Rivers presented special hazards to Civil War–era vessels, as they often had varying water flows that could lead to protruding rock hazards. Changing siltation patterns could cause the sudden appearance of sand bars, and often floating or sunken logs and trees could endanger the hulls of riverboats. Riverboats were shallow draft vessels designed to handle these types of hazards rather than to survive the high winds or large waves encountered at sea or on large lakes. (ALSC.)

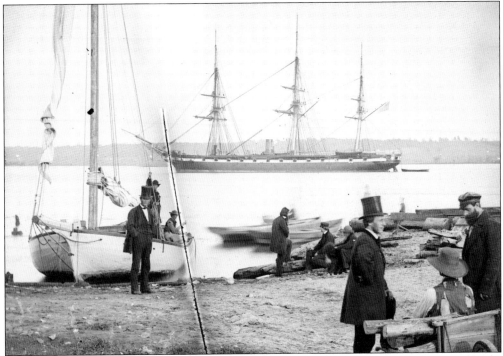

STEAM FRIGATE *PENSACOLA*. In March 1862, hundreds of vessels departed for the big push on Richmond. Pvt. Robert Sneden wrote, "The fleet began to slowly sail and steam down the Potomac amid the cheers of the soldiers, booming of guns in salute and the playing of several bands. . . . The glistening muskets and bayonets and the white sails of the sailing vessels gave an impressive effect."(LOC.)

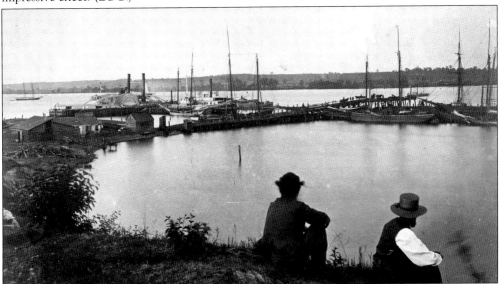

GOVERNMENT COAL WHARF. Alexandria became known as a national coal depot during the antebellum era. By the late 1850s, the coal trade had become so brisk that a shortage of transport vessels left between $20,000 and $30,000 worth of the black gold on the docks. After the Union occupation, coal continued to be stockpiled as one of the necessary ingredients of war. (LOC.)

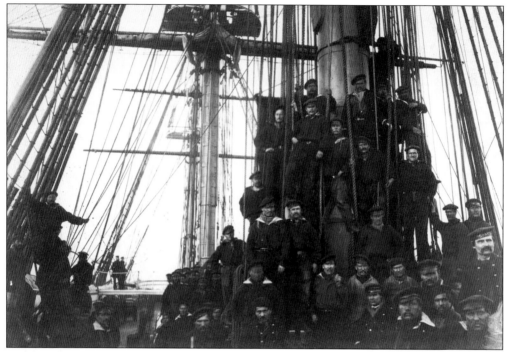

SAILORS ON RUSSIAN FRIGATE. In 1863, Tsar Alexander II of Russia sent a Russian fleet on a goodwill tour. The ships sailed up the Potomac in late October to call on President Lincoln and remained at anchor above Alexandria for several months. The visit of the Russian fleet provided a morale boost for the embattled Union. (LOC.)

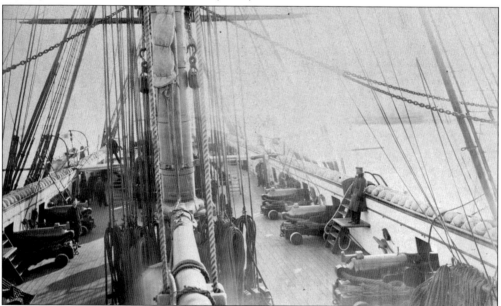

RUSSIAN FRIGATE OSLIABA. Pvt. Lewis Bissel wrote, "Tuesday Wilson Potter and myself went down to the city and boarded one of the Russian ships lying just above Alexandria. . . . We went to the water battery just below Alexandria where there is a fifteen inch Dahlgren gun which weighs 49449 pounds. At the largest part it measures a little over twelve feet in circumference." (LOC.)

Six

HOSPITALS AND PRISONS

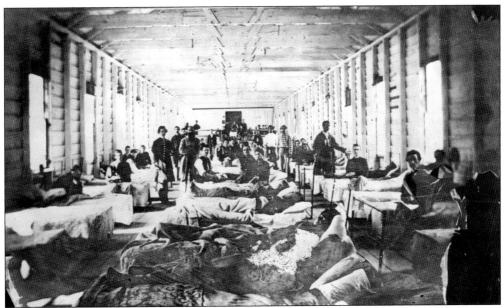

WOUNDED SOLDIERS IN ALEXANDRIA. Within Alexandria, large houses and four churches were converted into hospitals, resulting in 14 often-overcrowded facilities. The military also operated five prisons in Alexandria. The Mount Vernon Cotton Factory housed some 1,500 Confederate POWs in overfull and unsanitary conditions. Those held at the Washington Street prison were generally en route to prison camps in the North. Spies and enemy sympathizers were jailed at the Odd Fellows Hall. The Duke Street slave pen was used to house drunken and disorderly Union soldiers. Union deserters were imprisoned at Prince Street in the former Green's Furniture factory, which had been requisitioned by the army. The old Alexandria Jail, in use since 1826, was employed as well. Capt. Rufus D. Pettit served as superintendent of U.S. military prisons in Alexandria from 1864 to 1865. In November 1865, Pettit was court-martialed for his brutal treatment of prisoners, found guilty, and dishonorably discharged. (ALSC.)

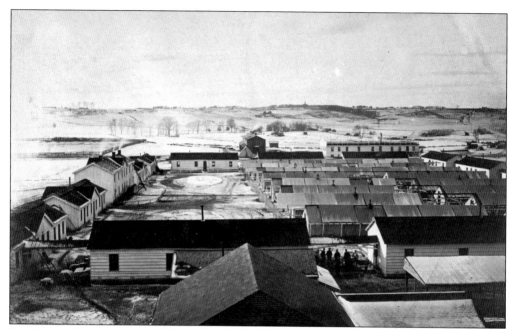

BIRD'S-EYE VIEW OF SICKEL HOSPITAL. Joshua Ingalls of the 149th Pennsylvania Infantry was shot through the chest at North Ana River on May 23, 1864. After spending the night on the battlefield, Ingalls was almost abandoned on the field by a harried surgeon. He found himself first in Washington and then in the hospitals of Alexandria. (LOC.)

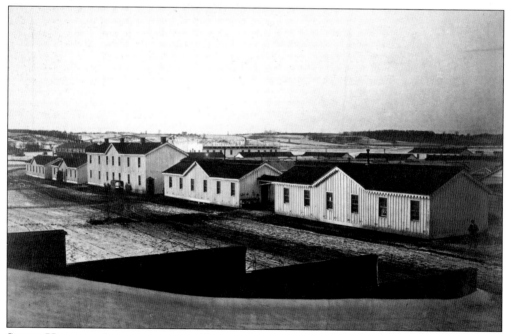

SICKEL HOSPITAL, LOOKING TOWARD FAIRFAX SEMINARY. Joseph Richardson wrote the following from this hospital: "It is useless for you to worry about me for I always do as well and a great deal better then those who are in the same occupation. I always have friends wherever I go and always can get along." (LOC.)

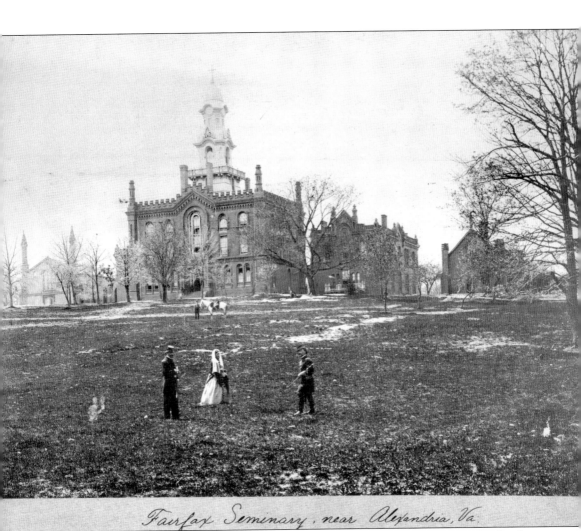

Fairfax Seminary, near Alexandria, Va.

EPISCOPAL SEMINARY HOSPITAL. Julia Wheelock came to Alexandria searching for her brother, and after learning of his death, she stayed to nurse the wounded. She wrote, "We all went out to Fairfax Seminary Hospital. . . . This is a large hospital and will accommodate several hundred patients. It is situated in a delightful place, . . . commanding a fine view of the country for miles around. It was formerly a theological seminary." When the war began, the U.S. Army medical staff consisted of the surgeon general, 30 surgeons, and 83 assistant surgeons. Of these, 24 resigned to return to the South. When the war ended, more than 11,000 doctors had served or were serving, many working under contract, often on a part-time basis. Most of the nursing service on both sides was voluntary; the U.S. Sanitary Commission performed invaluable work in nursing and relief, both at the front and in hospitals behind the line. (ALSC.)

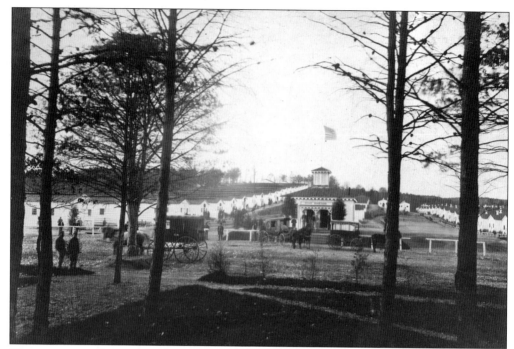

CONVALESCENT CAMP NEAR ALEXANDRIA ("CAMP MISERY"). "We are in tents, five in each tent, no beds, has to lie on the hard ground, which is not a comfortable bed for sick folks," recorded William Wallace of the 3rd Wisconsin Volunteer Infantry. (LOC.)

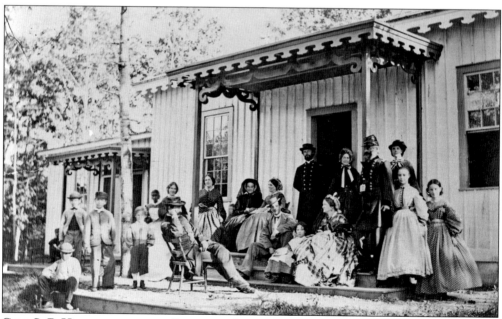

GEN. S. P. HEINTZELMAN AND GROUP AT CONVALESCENT CAMP. Wallace went on to report, "We don't get our cooking done not half the time for want of wood but who is to blame I am unable to say. But one thing I do know it is one of the meanest places I have come across." (LOC.)

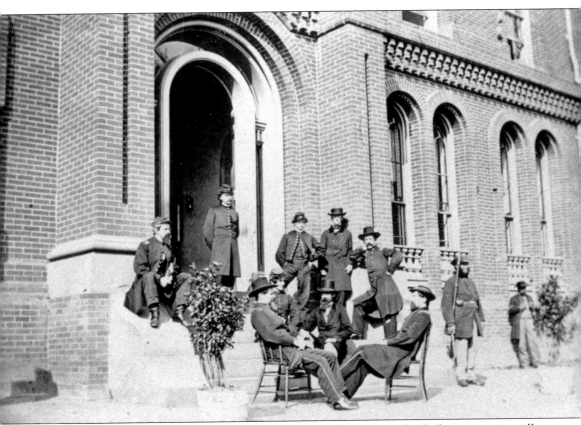

UNION TROOPS AT EPISCOPAL SEMINARY HOSPITAL. Patients and relief agents universally praised this facility, known as the best hospital in Alexandria. Superintendent Jane S. Woolsey ran a crisp and efficient organization, which also provided comfort. The well-equipped kitchen prepared dishes for patients on special diets and also made variations of Dutch and New England dishes. Except for the gelatin—flavored with brandy, sugar, and lemons—most of the food pleased the patients. Early in the war, there was a strong demand for the creation of a U.S. Sanitary Commission, patterned on the British Sanitary Commission, which had been formed to clean up the filth of the Crimean War. The commission persuaded highly respected doctors to write pamphlets on sanitation and hygiene. The group also persuaded a number of respected medical experts to examine recruit camps and to report on cleanliness and on the professional competence of surgeons to hold their commissions. (ALSC.)

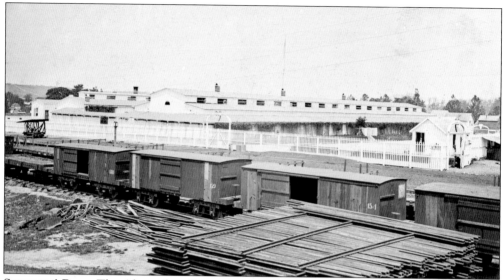

SOLDIERS' REST. The Alexandria Gazette of October 31, 1863, reported, "The Soldiers' Rest designed for the accommodation of U.S. troops arriving and remaining temporarily in this place, recently built at the upper end of Duke Street, . . . is said to be the largest and most complete establishment for this purpose contemplated, in the U.S. or anywhere else. It has sleeping apartments, bathing rooms, reading rooms, etc." (LOC.)

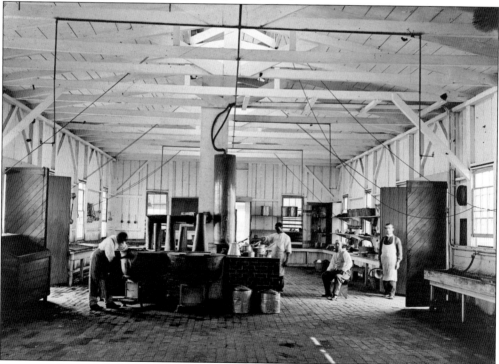

COOKS AT SOLDIERS' REST. Rations consisted of bread, fresh beef whenever possible, one pound of potatoes three times per week, and pork or bacon. To every 100 rations went 15 pounds of beans or peas and 10 pounds of rice or hominy, 10 pounds of green coffee or 8 pounds of roasted coffee, 1 pound 8 ounces of tea, sugar, vinegar, salt, pepper, and molasses. (LOC.)

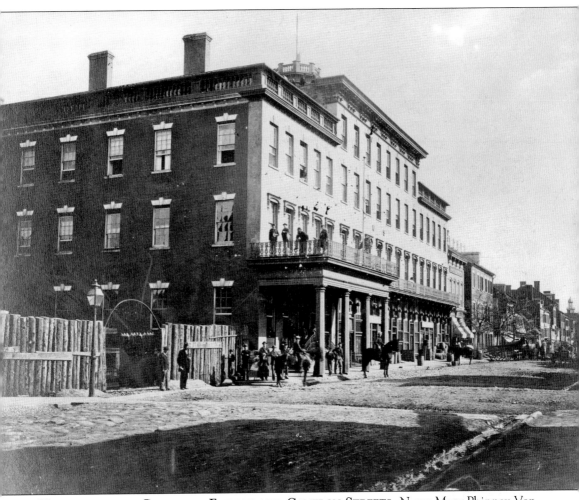

HOSPITAL AT THE CORNER OF FAIRFAX AND CAMERON STREETS. Nurse Mary Phinney Von Olnhausen wrote, "Such a sorrowful sight; the men had just been taken off the battlefield, some of them had been lying three or four days almost without clothing, their wounds never dressed, so dirty and wretched. . . . They reached town last evening, lay in the cars all night without blankets or food, were chucked into ambulances, lay about here all day, and tonight were put back into the ambulances and carted off again." Surgeons ignored both the slightly wounded and the mortally wounded in the interest of saving as many lives as possible. This meant special attention to arm and leg wounds. Injuries to the head, chest, and stomach were considered fatal. The frequency of amputations was questioned at the time. Yet considering the conditions of the patients, the difficulties of transportation, and the septic state of the hospitals, amputations probably saved lives. (ALSC.)

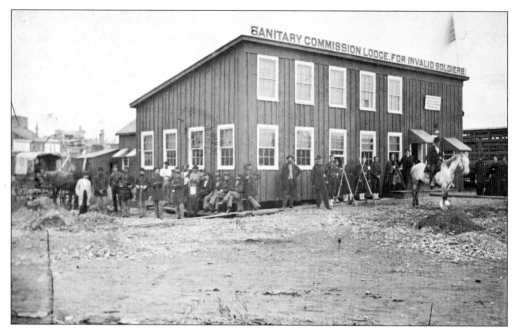

SANITARY COMMISSION LODGE. Created in 1861 by private citizens, the Sanitary Commission was recognized by the war department in June 1861. Its purpose was to promote clean and healthy conditions in the Union army camps. The commission staffed field hospitals, raised money, provided supplies, and worked to educate the military and government on matters of health and sanitation. (LOC.)

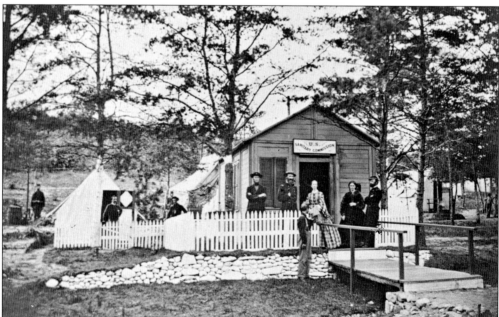

SANITARY COMMISSION AT CONVALESCENT CAMP. Many women volunteered to work for the Sanitary Commission, helping in field hospitals, organizing medical services, and acting as nurses. Others managed fund-raising efforts and the logistics of providing food, housing, and care for soldiers returning from battle. (LOC.)

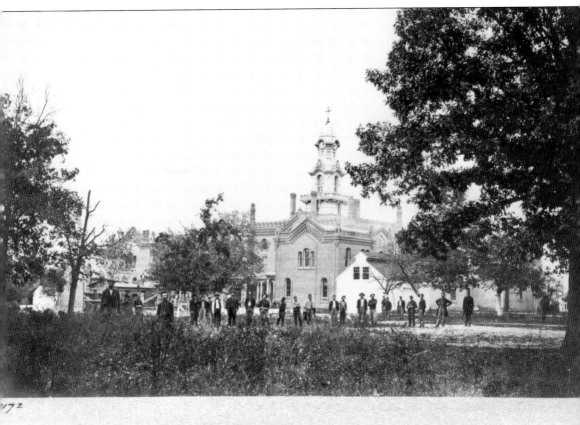

Fairfax Seminary, near Alexandria Va.

FAIRFAX SEMINARY. Hospitals were mostly hastily improvised and inadequate. Antiseptics were unknown, the relation of dirt to infection was generally not understood, and anesthesia was just coming into general use. Mortality from disease and wounds was far higher than from bullets. Hospitalization was often regarded as equivalent to a death sentence. An 1863 inspection of Union hospitals reported one-third of them to be bad or very bad. Buildings adapted for use as general hospitals were usually considered unsatisfactory because of the inadequate plumbing and ventilation. The staff, aside from the medical officers and nurses, was made up of the convalescents, who were weak and irritable. Female nurses were well liked by the patients and were not so much nurses as mother substitutes. They wrote letters for their "boys," read to them, decorated the wards with handsome garlands, and sometimes sang. (ALSC.)

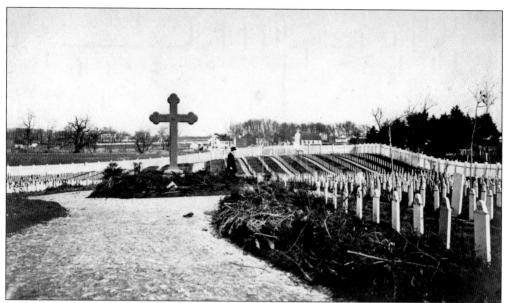

SOLDIER'S CEMETERY. "We had gone but a few steps when . . . we saw a soldier's funeral procession approaching—a scene I had never before witnessed, but one with which I was destined to become familiar. . . . He is escorted to his final resting place . . . by comrades . . . with unfixed bayonets, and arms reversed, keeping time with their slow tread and solemn notes of the 'Dead March,' " wrote Julia Wheelock. (LOC.)

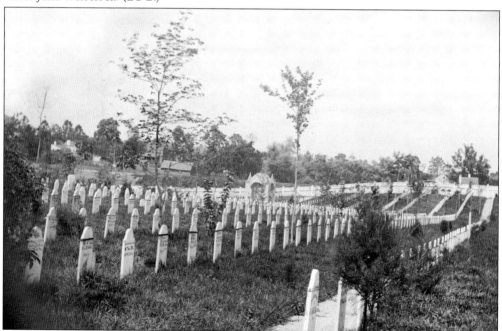

ONE OF THE FIRST CIVIL WAR CEMETERIES. On June 17, 1863, Pvt. Lewis Bissell recorded a funeral procession en route to Soldier's Cemetery. "The ambulances, seventeen in number, each with two coffins, were followed by officers and men. They marched to mournful music played by the First Connecticut Artillery band. . . . It was a sad sight to see the procession move towards the soldier's graveyard in Alexandria." (LOC.)

EPISCOPAL SEMINARY HOSPITAL, 1862. A nurse wrote in 1862, "The whole street was full of ambulances, and the sick lay outside on the sidewalks from nine in the morning till five in the evening. Of course, places were found for some; but already the house was full; so most had to be packed up again and taken off to Fairfax Seminary, two miles out." (LOC.)

QUEEN STREET HOSPITAL. The army relied heavily on contract surgeons, who were poorly paid and slowly promoted. These government contractors worked relatively unrestricted by the military and did as much harm as good. One surgeon ordered an amputee back to active duty. A drunken surgeon operated on a man's healthy limb while ignoring his fractured limb. Such incidents were common. (ALSC.)

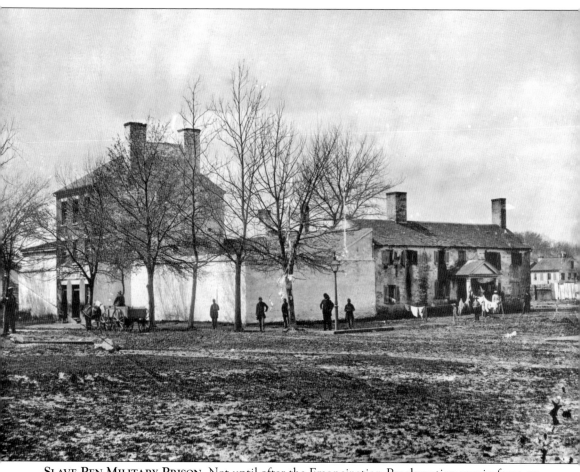

SLAVE PEN MILITARY PRISON. Not until after the Emancipation Proclamation was in force on January 1, 1863, did Union officers actively recruit African American soldiers. By the end of the Civil War, one out of every eight Union soldiers was a black man. This image is symbolic because black soldiers stand in front of a location where slaves were held, stripped, examined, and bought and sold at auction. Confederate prisoners accused the African American guards of cruelty. "Numbers of scars were left on the frame work of the closets made by negroes firing at the prisoners. The negro guard was very insolent and delighted in tantalizing the prisoners, for some trifle affair, we were often accused of disobedience and they would say, 'Look out, white man, the bottom rail is on top now, so you had better be careful for my gun has been wanting to smoke at you all day!'" (ALSC.)

COTTON FACTORY PRISON. In 1861, prisoners of war were exchanged right on the battlefield—a private for a private, a sergeant for a sergeant, and a captain for a captain. In July 1862, a more formal prisoner exchange system was agreed upon. All prisoners were to be discharged on parole and exchanged within 10 days according to a set ratio (for example, a private for a private, or 60 privates for 1 general). The agreement broke down because the Confederate government insisted on treating captured black Union soldiers who had been slaves as "runaway" slaves. The failure of the exchange system led to the creation of large holding pens for prisoners in both the North and the South. The prisons in Alexandria were used as intermediate stops for Southern prisoners on their way North. (ALSC.)

ALEXANDRIA CITY JAIL. Rowdy troops roamed the streets, forcing local residents to remain in their homes. It was just too dangerous to go out. Mrs. Robert Jamieson was wounded by a young soldier in a shooting accident. Mary Butler died of a gunshot wound inflicted by a drunken soldier. Her murderer was executed. A trooper from the 16th New York wrote, "The men who were put into the Alexandria jail tested its capacity." Like the Alexandria City Jail, bursting with inmates, most prisons in the city were overcrowded, with the prisoners lacking decent clothes, shelter, or food. Medical services were minimal. Jails came under further strain in late 1863 when the Union refused to honor the exchange of prisoners. General Grant said, "Every man we hold, when released on parole or otherwise, becomes an active soldier against us at once either directly or indirectly. If we commence a system of exchange which liberates all prisoners taken, we will have to fight on until the whole South is exterminated." (ALSC.)

Seven

FORTS

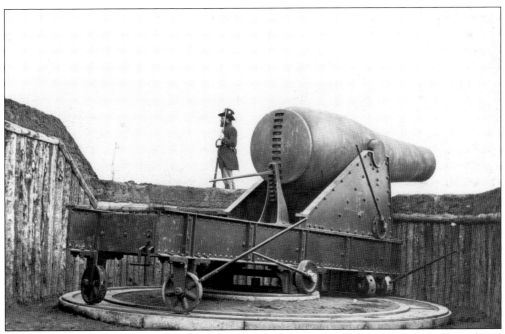

GUNS ALONG THE POTOMAC. The federal capital was protected by 68 major forts linked by military roads and rifle trenches. Besides Fort Ward, other forts near Alexandria included Fort Lyon, Fort Ellsworth, and Battery Rodgers, constructed along the Potomac River. The giant, 15-inch Rodman gun at Battery Rodgers was one of the largest in the world at the time of the Civil War. In 1863, federal authorities braced for a possible Confederate attack on Alexandria. "For the last week all sorts of rumors have been afloat of the invasion of Alexandria: preparations have been making all around, rifle pits dug everywhere, . . . even the bridge made ready to be destroyed at a moment's notice, and no one permitted to go out of town. . . . For here lie all the stores for the whole Army of the Potomac," wrote Mary Phinney Von Olnhausen. (ALSC.)

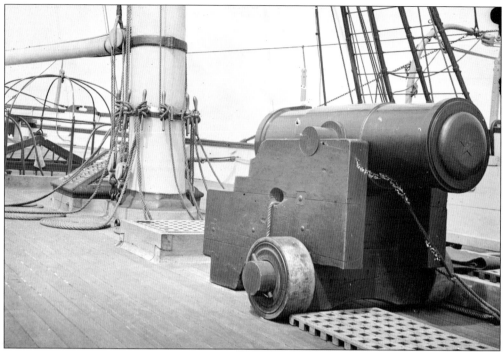

USS PAWNEE. This 1,533-ton light-draft steam sloop of war was built at the Philadelphia Navy Yard in Pennsylvania. In 1861, *Pawnee* served on the Potomac River, assisting with the defense of Washington, D.C., and participating in the North's initial offensive operations against Virginia. Among her activities during this time were the occupation of Alexandria and artillery duels with Confederate batteries at Aquia Creek. (LOC.)

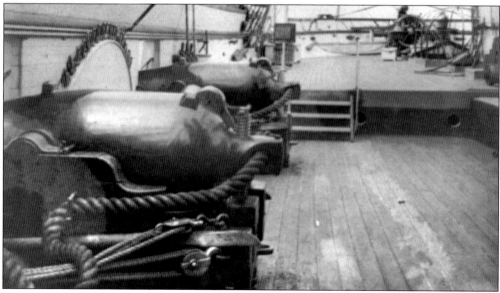

DECK OF THE USS PAWNEE. In the spring of 1861, tensions on the Potomac River grew. The federal gunship *Pawnee* sailed into the river on May 11. Armed with eight large guns, the *Pawnee* began lying in the river, "grinning, and showing her teeth to frighten poor Alexandrians," wrote Anne Frobel. (LOC.)

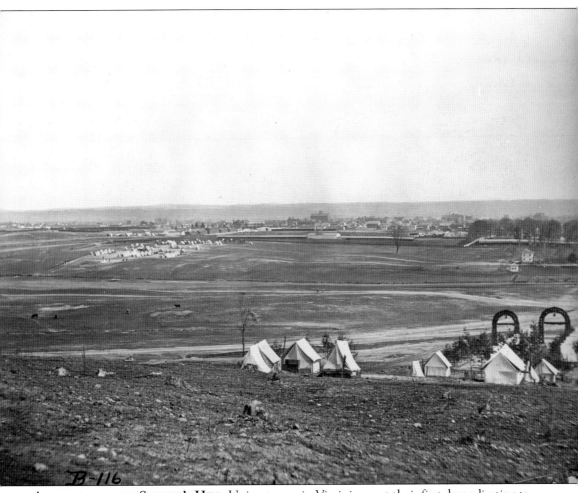

ALEXANDRIA FROM SHUTER'S HILL. Union troops in Virginia spent their first days adjusting to the hardships of camp life. For enlisted men, their days in the forts began at dawn. Drills, repairs, duties, parades, and inspections consumed the days. "The time passed pleasantly enough," wrote one soldier, spared from hardships in the field. The routine of most troops early in the war also meant digging earthworks to protect Washington. Picket duty was also important, especially with the enemy so near the capital. Sniping occurred often enough to keep guards awake and alert. Capt. Howard Kitching of the 2nd New York Light Artillery recorded, "When we came in here [Fort Ellsworth] . . . it was occupied by four hundred 'man-of-war's men': in fact, a complete frigate's crew—and they have been spending the past two months in putting the fort in order." (ALSC.)

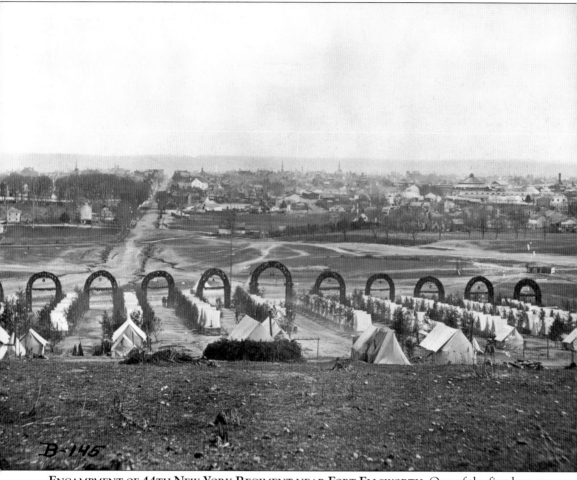

ENCAMPMENT OF 44TH NEW YORK REGIMENT NEAR FORT ELLSWORTH. One of the first heroes to fall was Col. Elmer E. Ellsworth. While Ellsworth's body lay instate in the capitol at Albany, New York, the patriotic people of that city decided to raise a regiment from the state at large, in honor of the fallen hero. The plan was to select one man from each town and ward. The regiment was mustered into the United States service on September 24, 1861. An observer recorded the arrival of Union army units: "Trains of cars closely following each other, and daily and nightly deposited thousands of men from the Eastern, the Middle, the Northern, and the Western states. All these were marching to and fro, seeking and constructing their camps. The hills were white with tents; the plains glistened with the arms of moving troops." (ALSC.)

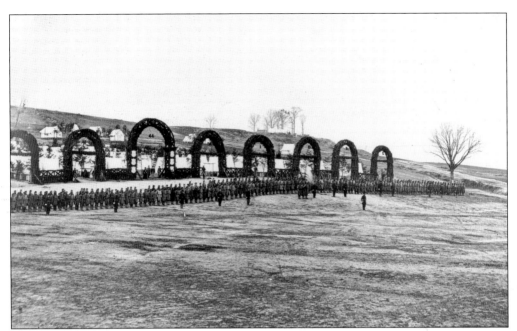

NEW YORK 44TH REGIMENT ON SHUTER'S HILL. "Last evening at eleven o'clock, those of us who were up, were very much excited by discovering that the brigade . . . numbering some five thousand men were leaving their camps and taking up their line of march toward Fairfax," wrote Capt. Howard Kitching. (ALSC.)

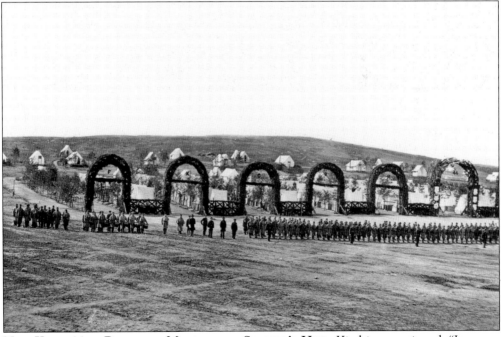

NEW YORK 44TH REGIMENT MASSING ON SHUTER'S HILL. Kitching continued, "It was as beautiful sight as my eyes ever beheld. Our position is on a very high and steep hill . . . and as the different regiments left their camps and filed out into the plain below, their bayonets glistening in the unusually brilliant light of the moon." (ALSC.)

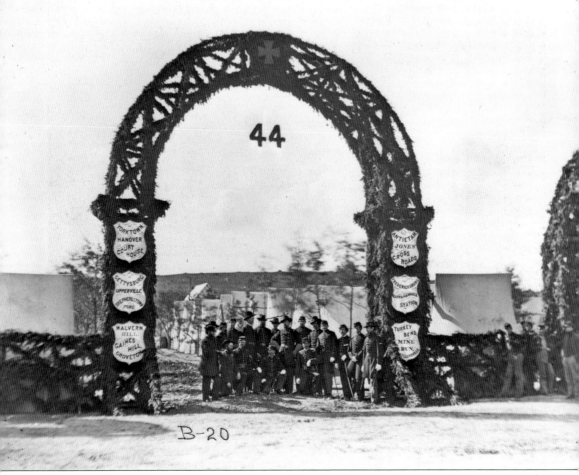

GATE OF 44TH ENCAMPMENT WITH BATTLE HONORS DISPLAYED. No two forts were exactly alike. Laborers piled up earthworks so that parapets 12- to 18-feet thick faced exposed fronts. Within the ramparts, field and siege guns were mounted on platforms to lay down a wide angle of fire. Outside the earthworks, a steep slope led down to a dry moat. Beyond this ditch, felled trees with sharpened branches pointing outward ringed the fort. Work parties cleared all brush and trees in front of the fort for up to two miles, leaving no cover. As the Battle of Gettysburg raged in July 1863, federals feared that Alexandria would be attacked. One soldier wrote, "They are blockading the City of Alexandria very strong for they expect attack here. Our regiment has laid out in the field for some time every night, watching for the rebels. . . . There is three regiment of infantry here and one of Cavalry and some flying artillery." (ALSC.)

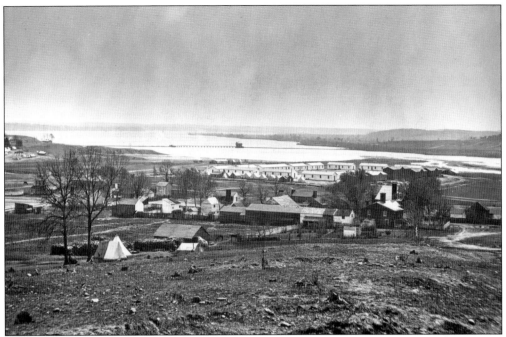

LOOKING TOWARD THE POTOMAC FROM SHUTER'S HILL. In September 1862, after the Second Battle of Manassas, thousands of stragglers from the defeated Union army poured into Alexandria. Many claimed to be guards of trains or baggage. To contain them, a temporary convalescent camp was set up on Shuter's Hill near Fort Ellsworth. (ALSC.)

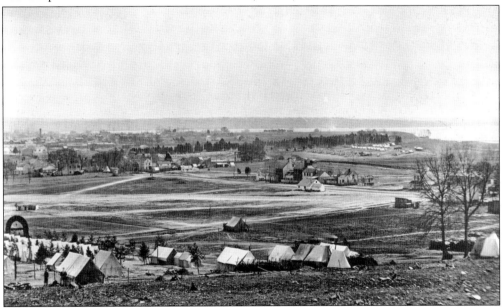

LOOKING FROM SHUTER'S HILL TO RAILROAD YARD. General Haupt was a man of considerable self-confidence and strong opinions, even suggesting strategic maneuvers to General Burnside and criticizing General Meade. As the war progressed, he continually suggested ideas and offered criticism to military and political superiors on all matters, some far removed from military logistics. (ALSC.)

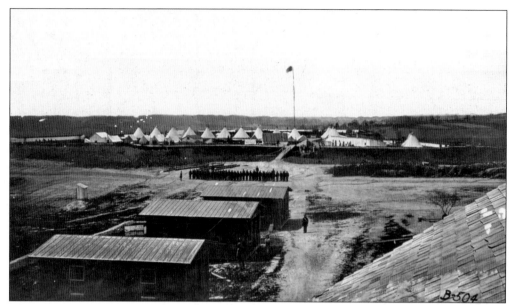

FORT ELLSWORTH ON SHUTER'S HILL. "Now we are in Fort Ellsworth. . . . It is a very fine piece of work on a splendid commanding position, overlooking Washington, Alexandria, and all the surrounding country, for fifteen or twenty miles," recorded Capt. Howard Kitching. (ALSC.)

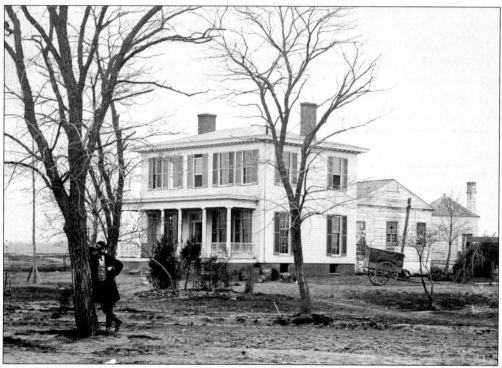

GEN. SAMUEL P. HEINTZELMAN'S HEADQUARTERS AT FORT LYON. "Tuesday the ninth of June [1863] at about 2 O'clock in the afternoon . . . [there] came a stunning crash. . . . Immediately shells were flying over our heads. . . . We learned that the explosion has occurred in Fort Lyon," wrote Pvt. Lewis Bissell. (LOC.)

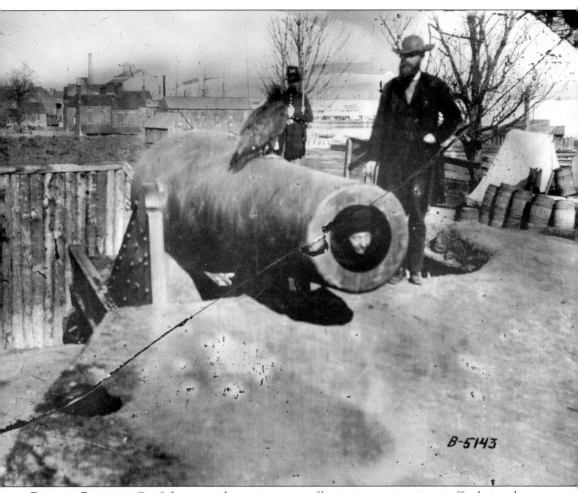

BATTERY RODGERS. Confederate gun batteries were so effective in stopping river traffic during the fall and winter of 1861–1862 that a foreign correspondent reported Washington as the only city in North America under blockade. In addition to the gun batteries, the Confederates employed a captured steamer, renamed the CSS *City of Richmond*, to terrorize the river. During this period, all ships carrying federal shipments were directed to Baltimore to unload. Originally named the Water Battery, the installation was renamed in 1863 to honor navy captain G. W. Rodgers, hero of a naval attack on Charleston, South Carolina. The installation had its own hospital, slaughterhouse, and barracks. Armaments included five 200-pound Parrott guns and a 15-inch Rodman gun. The heaviest type of cannon in the Union arsenal, the Rodman gun could fire a 302-pound shell. (ALSC.)

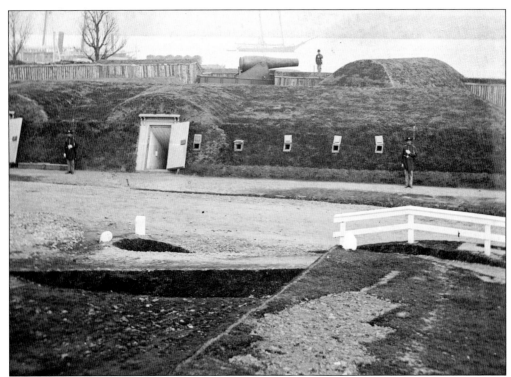

BATTERY RODGERS, OVERLOOKING THE POTOMAC NEAR JONES POINT. Battery Rodgers was built to guard Washington from potential threats advancing up the Potomac River. After the First Battle of Manassas in July 1861, the Confederacy built gun batteries along the Potomac 35 miles south of Washington. These effectively closed the Potomac River. (LOC.)

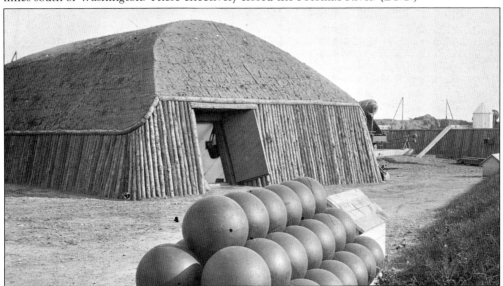

MAGAZINE IN BATTERY RODGERS. The Battery Rodgers guns were supported by two powder magazines. The complex included a hospital, barracks, mess hall, and prison. After the war, the battery was dismantled and its guns removed to other locations in Washington. The land was sold soon afterward. (LOC.)

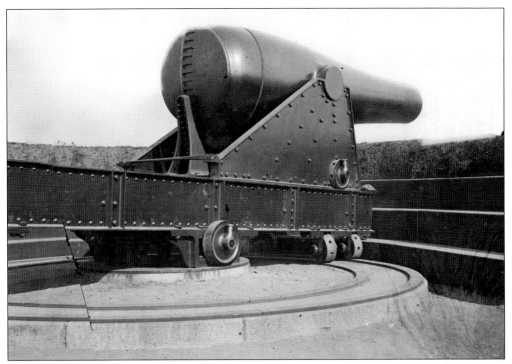

RODMAN GUN IN BATTERY RODGERS. From its position on a 28-foot cliff, the battery was positioned with a clear view of fire and was well suited to guard the approaches to Washington. During the war, Battery Rodgers mounted five Parrott artillery pieces and a 15-inch Rodman gun, one of the largest in the world at that time. (LOC.)

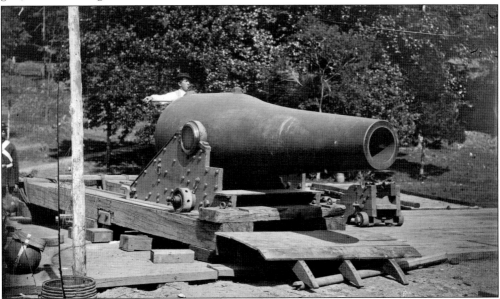

GUN AND MOUNTING. "Just at the corner of our hospital and just under my window [a rifle pit] is dug, and a battery of four guns planned. . . . and since I began to write up comes the orderly, counts every man in the hospital able to shoulder a gun, and arms them all, so that at a moment's warning they may be ready," wrote Mary Phinney Von Olnhausen in May 1863. (LOC.)

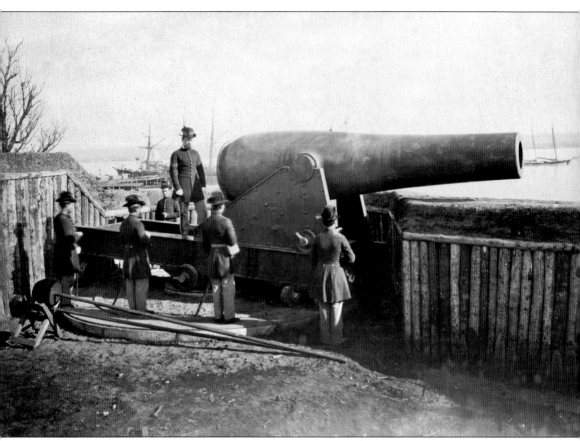

WATCHING FOR THE IRONCLAD. The South almost turned the naval balance of power around when it was the first to commission an operational ironclad. On the afternoon of March 8, 1862, the CSS *Virginia* (*Merrimack*) sailed toward the entrance of the James River, attacking the wooden ships of the Union fleet. Panic spread throughout Washington as news of the destruction of the wooden ships flowed into the city. Washingtonians waited to be shelled by the ironclad monster. An officer asked President Lincoln, "Who is to prevent her from dropping her anchor in the Potomac . . . and throwing her hundred pound shells into this room, or battering down the walls of the Capitol?" Lincoln replied, "The almighty," but together with members of his cabinet, continued looking down the Potomac for a sign of the CSS *Virginia*. (LOC.)

FORT WARD. Named for the first Union naval officer to die in the Civil War, Fort Ward was positioned on high ground just west of the intersection of three key transportation routes. At first, Union soldiers worked on the fortifications. Construction was eventually taken over by hired laborers, including hundreds of former slaves who had fled to the protection of the Union army around Washington. Corp. Frederick Floyd of the 40th New York Infantry described the completion of Fort Ward. "On Wednesday, Sept. 4, a flag was raised within the enclosure, at which time 3000 soldiers jumped upon the ramparts and gave three hearty cheers for the stars and stripes, which floated in sight of the enemy on Munson's Hill, where they have a battery. The fort was built almost entirely by the Mozart Regiment." (ALSC.)

ONE OF THE 68 FORTS GUARDING WASHINGTON. On Christmas Eve 1860, the Cary family entertained guests at Vaucluse, their home two miles west of Alexandria, with eggnog and apple toddy around the fireplace. A blazing Yule log warmed the room. Few could have imagined that Vaucluse would soon lie in ruins, its forests ravaged by the occupying Union army erecting earthworks in the construction of Fort Ward. During the war, freedmen who helped on the construction of the fort bought small plots of land nearby, built houses, and started churches and schools. Fort Ward never came under Confederate attack, and the five-acre fort was dismantled in November 1865. An African American community called the "Fort" or sometimes "Fort Hill" continued on the site into the 20th century. (ALSC.)

Eight

ALEXANDRIA COUNTY AND NORTHERN VIRGINIA

HARPERS FERRY. The placid scene of Harpers Ferry, Virginia, in 1859 belied the fact of impending conflict. In October, abolitionist John Brown seized the federal arsenal at Harpers Ferry. Brown had come to lead a slave uprising. On the morning of October 18, a storming party of marines under the overall command of Alexandria's Robert E. Lee took Brown prisoner. Charged with "conspiring with slaves to commit treason and murder," Brown was tried, convicted, and hanged in Charles Town on December 2, 1859. The Alexandria Gazette proclaimed, "Virginia has been invaded . . . actually, deliberately, and systematically invaded . . . by an organized band of miscreants, white and black, from Free States, under the lead of a Kansas desperado, at the instigation and appointment of influential and wealthy Northern Abolitionists!" (LOC.)

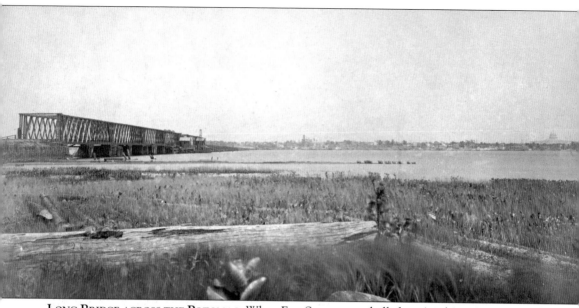

LONG BRIDGE ACROSS THE POTOMAC. When Fort Sumter was shelled on April 14, 1861, President Lincoln issued a call for 75,000 troops. The first Union troops crossed the Potomac River into Alexandria County during the early morning hours of May 24, 1861, the effective date of Virginia's vote of secession. Some troops went by water; others crossed the Potomac River bridges. An officer reported that moonlight glittered on the flashing muskets as the regiment silently advanced across Long Bridge. The only opposition encountered by Union troops was from scattered pickets at the southern end of the bridge. Confederate volunteer units organized in the city of Alexandria withdrew. Of the invading force, 2,200 men of the 11th New York Fire Zouaves and the 1st Michigan Volunteers occupied Alexandria. (LOC.)

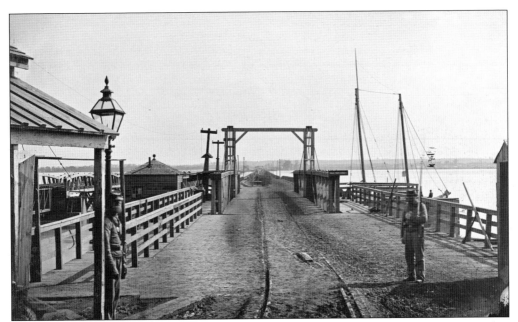

WASHINGTON SIDE OF LONG BRIDGE. By the time the first Union troops arrived in Alexandria County, many officials known to be Confederate sympathizers had left. They included military and law enforcement officers as well as the clerk of courts. People who remained were Union sympathizers or "quiet" Confederates. (LOC.)

ARLINGTON HOUSE. Col. Robert E. Lee, the most prominent resident of Alexandria County, was offered command of the Union army on April 18, 1861, but declined. He left his home at Arlington House for the last time on April 22 and accepted command of the Virginia forces. After the federal invasion, Arlington House was occupied by the 8th New York State Militia. (LOC.)

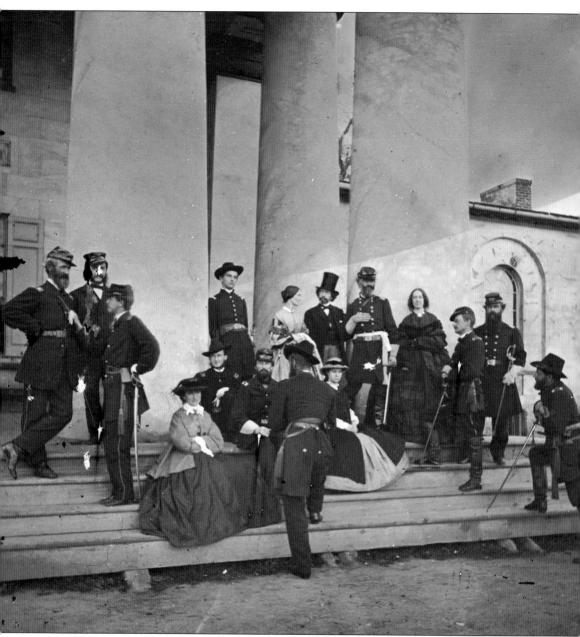

GENERAL HEINTZELMAN AND STAFF. Eight Union regiments crossed the Potomac River into Virginia on May 24, 1861. The first unit moved via the Aqueduct Bridge (now Key Bridge) from Georgetown and camped near present-day Clarendon. The second unit, the 7th New York Infantry under Samuel P. Heintzelman, marched over Long Bridge (the Fourteenth Street Bridge) and reached the Virginia side about 4:00 a.m. The third proceeded by water to the city of Alexandria. The earliest fortifications in Arlington took about seven weeks to build (until mid-July 1861). Forts were hastily erected, trenches cut, trees felled, and encampments built. General Heintzelman commanded the 2nd Michigan Infantry, which was responsible for the raiding, ransacking, and devastation of the Pohick Church in Lorton, Virginia, on November 12, 1861. (LOC.)

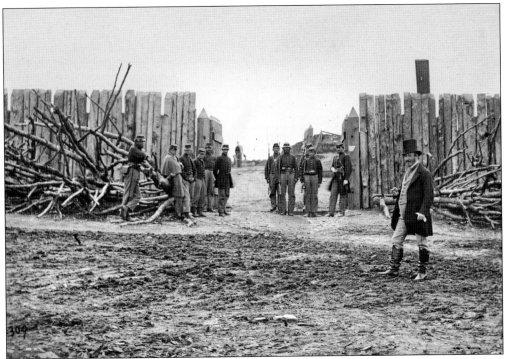

FORT CORCORAN. The first forts were built to protect the bridges across the Potomac. Fort Corcoran overlooked the Aqueduct Bridge. To aid in protection, federal troops constructed Fort Bennett (above Rosslyn) and Fort Haggerty (opposite Roosevelt Island). Private property was seized without regard to the owners. (LOC.)

UNION SUPPLY WAGON. Although much freight moved by rail, wagons were also heavily used. The six-mule wagon could haul loads of 3,400 pounds on good roads, 2,700 pounds on poor roads, and 1,800 pounds on bad roads. A total of 125 wagons was normally required to transport food for 10,000 men. (LOC.)

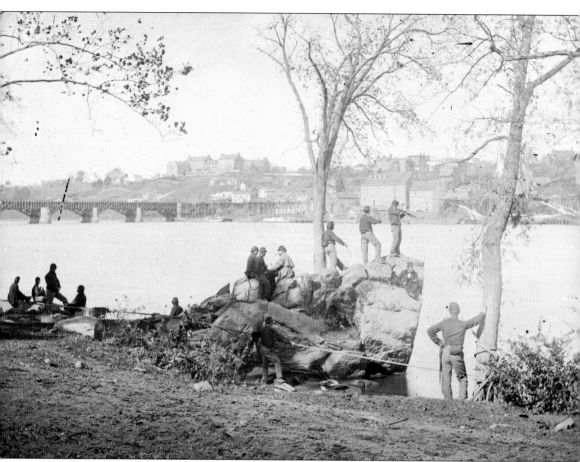

GEORGETOWN, AS SEEN FROM ALEXANDRIA COUNTY. With the arrival of Northern troops in 1861, Georgetown's Southern sympathizers crossed over into Virginia. By July of that year, many thought the first battle—about to be fought in Manassas, Virginia—would end the war. A carnival atmosphere arose around prospects of the coming battle. People took picnic baskets and headed out to watch. Cannon fire could be heard in Alexandria on July 21. The battle was a decisive Confederate victory. Union troops fled, straggling into Alexandria and Washington over the next few days. A Union sympathizer wrote, "Most of them had not eaten since Sunday morning. . . . They sat on doorsteps and curbstones from one end of our streets to the other. . . . Two . . . advised us to leave immediately, for they thought Beauregard would be in Alexandria before night." (LOC.)

ALEXANDRIA COUNTY HEADQUARTERS OF GEN. IRWIN MCDOWELL. McDowell was the Union commander at the First Battle of Manassas on July 21, 1861. A Union sympathizer reported on the retreat to Alexandria: "They came in squads without officers and knew not where to go. Many were so exhausted . . . that they could scarcely stand." (LOC.)

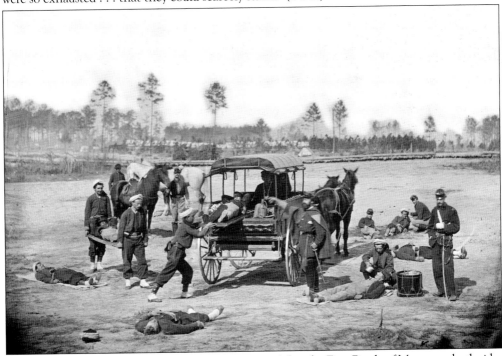

ZOUAVE AMBULANCE CREW ON THE BATTLEFIELD. After the First Battle of Manassas, both sides realized that the war was not going to be short. The military recognized the need to radically improve defenses for Washington and to retrain and better equip the Union army. (LOC.)

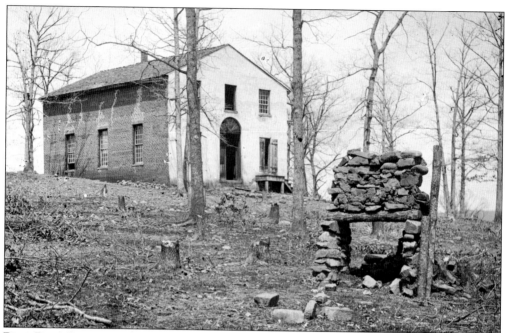

BULL RUN, SUDLEY CHURCH. Landon Carter donated three-quarters of an acre of land to build Sudley Church. This first church building was erected sometime between 1822 and the early 1840s. Services were held by circuit riders and lay leaders. Sudley Church was used as a military hospital in July 1861 during First Manassas and in August 1862 during Second Manassas. (LOC.)

RUINS OF THE HENRY HOUSE ON THE MANASSAS BATTLEFIELD. The 85-year-old Judith Carter Henry refused to leave her bedroom as the First Battle of Manassas raged on the hill surrounding her home. Snipers used the house, and Judith was killed by a bullet meant for the snipers. The Second Battle of Bull Run was also fought on this hill in August 1862. (LOC.)

RUINS OF STONE BRIDGE AT BULL RUN. "You will read of the retreat from Bull Run—that battle was Sunday, July 21, 1861. We heard the firing of cannon all day. . . . The retreat of our men began about 5 P.M. I knew nothing of it till next morning, when squads of soldiers began to arrive in Alexandria from the battlefield," recorded Alexandria Unionist John Ogden. (LOC.)

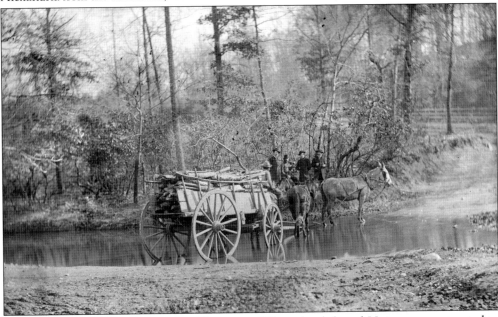

MULE TEAM CROSSING BROOK IN VIRGINIA. When the defeated Union army retreated to Alexandria and Washington, it fell back on its replenishing railheads. Federal forces were able to regroup and rearm before the Confederate army could exploit its victory at First Manassas. Washington was saved. (LOC.)

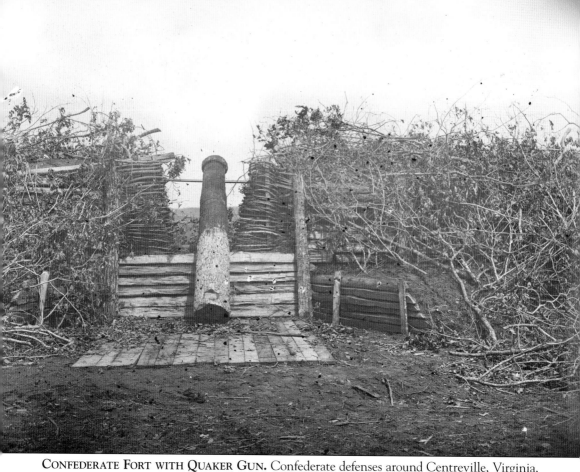

CONFEDERATE FORT WITH QUAKER GUN. Confederate defenses around Centreville, Virginia, intimidated Union forces until March 1862 when they were abandoned. Union troops found that many of the formidable cannons they faced were nothing but painted logs ("Quaker guns"). Quaker guns, used by both sides during the Civil War, were first employed during the Revolutionary War. The name derives from the Quaker religious opposition to war. Confederate general Joseph E. Johnston placed Quaker guns in his fieldworks around Centreville to indicate that the works were still occupied when, in fact, the Confederates were withdrawing to the south. Centreville has been historically designated as the town most destroyed by the Civil War. Troops cut all the trees to provide wood for cooking and warmth, to build log shelters, and to corduroy the roads. (LOC.)

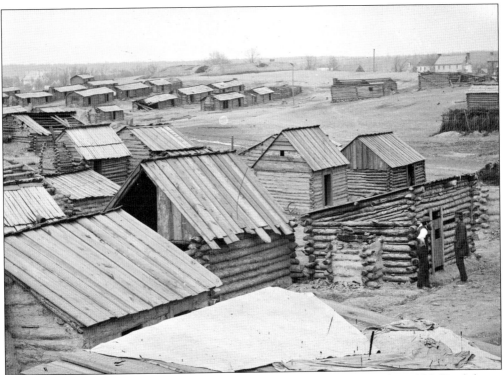

CONFEDERATE WINTER QUARTERS. Unable to defend the city, Alexandria's 800 Confederate volunteers marched down Duke Street to the railroad station, where they boarded an Orange and Alexandria Railroad train to Manassas Junction. At Manassas Junction, they joined other Confederate forces, fought in the First Battle of Manassas, and took up winter quarters in Centreville. (LOC.)

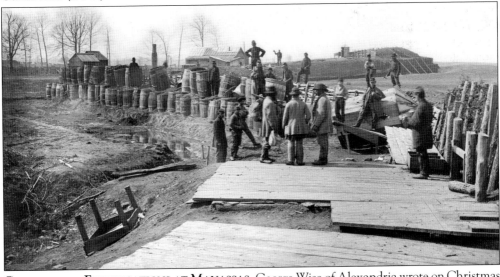

CONFEDERATE FORTIFICATIONS AT MANASSAS. George Wise of Alexandria wrote on Christmas 1861, "Many of the soldiers at Centerville, during the winter of 1861 received gifts from their distant homes to replenish their larders; but [we] were not so lucky, as our homes were in the hands of the enemy. . . . We tried to bear it heroically, though no gentle hand was near to soothe." (LOC.)

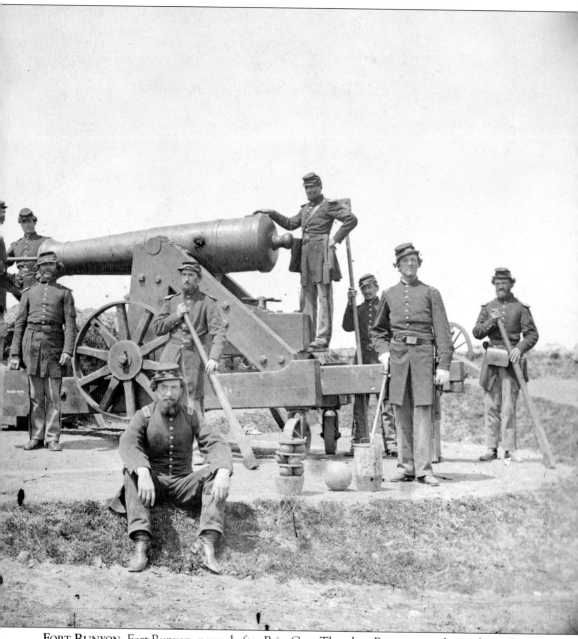

FORT RUNYON. Fort Runyon, named after Brig. Gen. Theodore Runyon, was located astride the important junction of the Washington, Alexandria, and Columbia Turnpikes, a half-mile south of Long Bridge. The fort was built on the land of a Washington building contractor in July 1861. The largest in the defenses of Washington, Runyon covered 12 acres and had a perimeter of 1,484 yards. Construction began on May 24, 1861, and was completed in seven weeks. Fort Albany was built on the high ground to protect the rear of Runyon. Fort Runyon was a pentagonal earth and timber fort approximately the same size and shape as the modern-day Pentagon. Interestingly, the Pentagon now stands on almost the exact site. A history marker now identifies where the fort once stood. (LOC.)

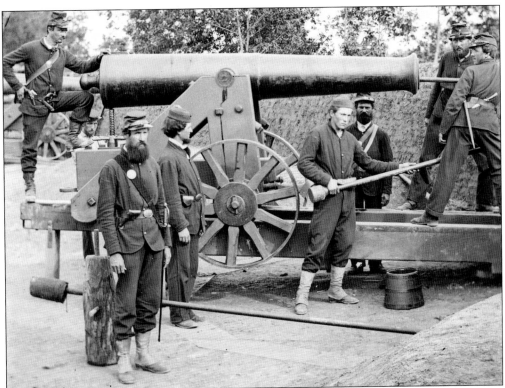

FORT WOODBURY. Defenses were strengthened by connecting all forts from Fort Corcoran to Fort Albany (from Key Bridge to the Fourteenth Street Bridge). A number of lunettes were built: Forts Craig, Tillinghast, Cass, and Woodbury. Next, Fort DeKalb (later called Fort Strong) was constructed near today's Lee Highway and Spout Run Parkway. In 1863, new works were added: Forts Whipple, Berry, and C. F. Smith. (LOC.)

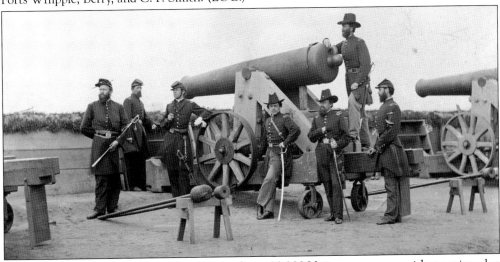

SOLDIERS WITH 24 PDR SIEGE GUN. More than 100,000 Union troops were either stationed at the 22 forts and other encampments in Alexandria County or swarmed through the "gateway" to and from the South during the four years of war. By the end of the conflict, the county was entirely devoted to the defense of Washington. (LOC.)

FALLS CHURCH. The church for which the city was named was first built in 1734. The present-day brick church, designed by James Wren, replaced the wooden one in 1769. By 1861, Falls Church had seen the arrival of many Northerners seeking land. The township's vote for secession was about 75 percent for and 25 percent against. (LOC.)

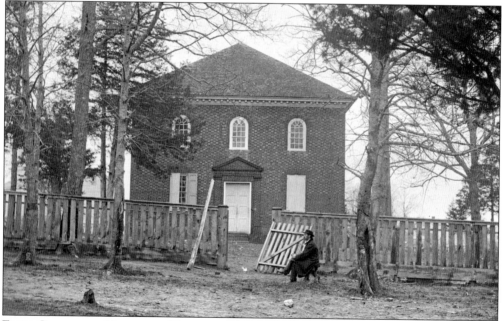

FALLS CHURCH IN NORTHERN VIRGINIA. The 83rd Pennsylvania Infantry, camped near Falls Church, confiscated fences and gates for firewood and even harvested five acres of potatoes. Volunteers of the 40th New York took pride in their nickname, "Forty Thieves," because they could find plunder where others failed. (LOC.)

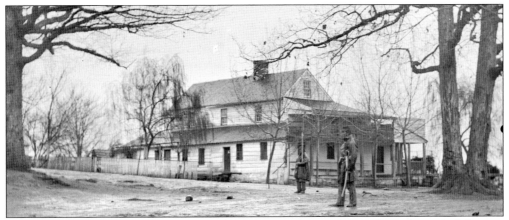

TAYLOR'S TAVERN. Fall's Church changed hands several times during the early years of the war. Confederate general James Longstreet once made his headquarters in the township. The world's first wartime aerial reconnaissance was carried out from Taylor's Tavern (near Seven Corners) by Thaddeus Lowe. (LOC.)

BALLOON INTREPID. Thaddeus Lowe organized an Aeronautical Corps in the U.S. Army. On September 24, 1861, he ascended to more than 1,000 feet near Arlington, Virginia, across the Potomac River from Washington, D.C., and began telegraphing intelligence on the Confederate troops located at Fall's Church, Virginia. This triumph led secretary of war Simon Cameron to direct Lowe to build four additional balloons. (LOC.)

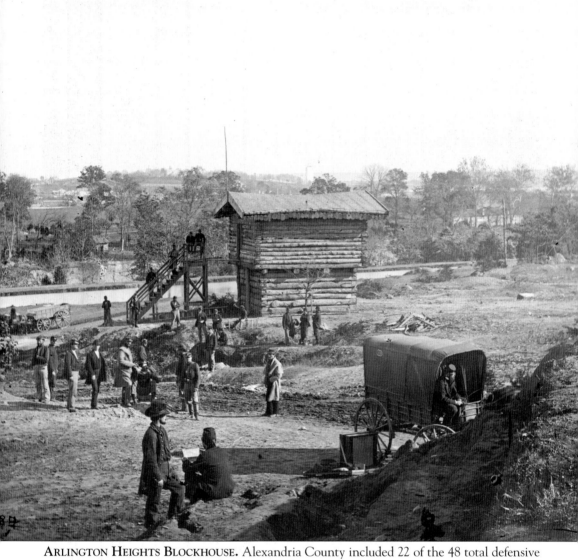

ARLINGTON HEIGHTS BLOCKHOUSE. Alexandria County included 22 of the 48 total defensive works constructed during the entire war. In 1864, the county's forts were stripped of able-bodied and disciplined infantry to provide replacements for General Grant's army as it pushed south toward Richmond (Wilderness, Spotsylvania, Cold Harbor, Petersburg). Confederate general Jubal Early took advantage of the situation and made a lunge at Washington. This invasion caused panic in the North as Early approached the outskirts of the capital. He sent his cavalry to the west side of Washington, while his infantry attacked Fort Stevens. President Lincoln watched the battle as the only sitting U.S. president to come under hostile military fire. Early summed up the situation when he said, "We haven't taken Washington, but we scared Abe Lincoln like hell." (LOC.)

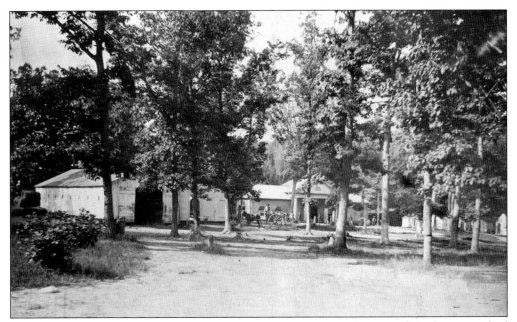

Hay Barns and Barracks around Arlington House. The large number of impoverished freed slaves and contraband created a problem. In May 1863, the quartermaster of the Washington Military District recommended their resettlement in the "pure country area" of Robert E. Lee's Arlington estate in Alexandria County. Freedman's Village, Arlington, one of many throughout the country, was formally opened on December 4, 1863. (LOC.)

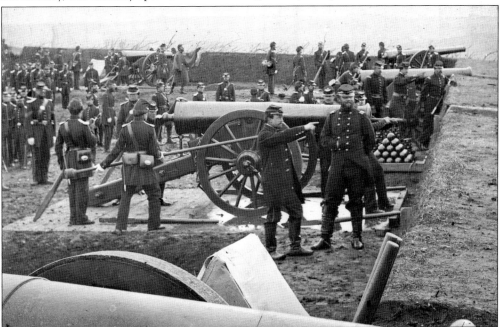

Fort Richardson. Union troops stationed in Alexandria County before 1864 were said to have a "soft assignment" because of the lack of action. An enlisted man wrote home, "With exception of drilling, guard mounting and inspection of knapsacks, we had but little to do, the time passed pleasantly enough, each day shortening our term of service." (LOC.)

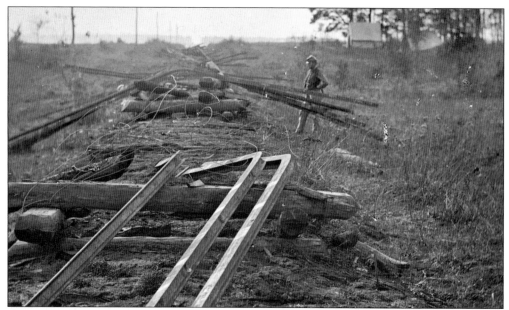

BRISTOE STATION. In October 1863, the Confederates attacked at Bristoe Station near Manassas without proper reconnaissance. Union soldiers, posted behind the Orange and Alexandria Railroad embankment, mauled two Confederate brigades of Henry Heth's division and captured a battery of artillery. After minor skirmishing near Manassas and Centreville, the Confederates retired slowly to the Rappahannock River, destroying the Orange and Alexandria Railroad as they went. (LOC.)

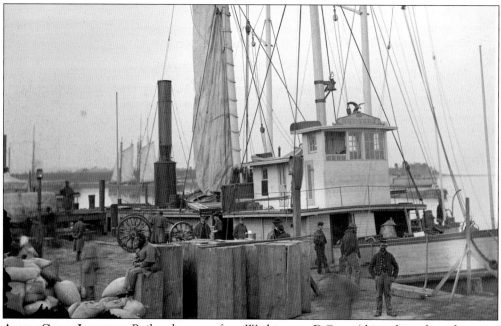

AQUIA CREEK LANDING. Railroad cars ran from Washington, D.C., to Alexandria, where they were then loaded onto barges carrying eight cars apiece. Steam-powered tugs took the barges to Aquia Creek, where the cars were reassembled into trains and run to the front opposite Fredericksburg. A 16-car train could travel from Washington to the Fredericksburg area in 12 hours. (LOC.)

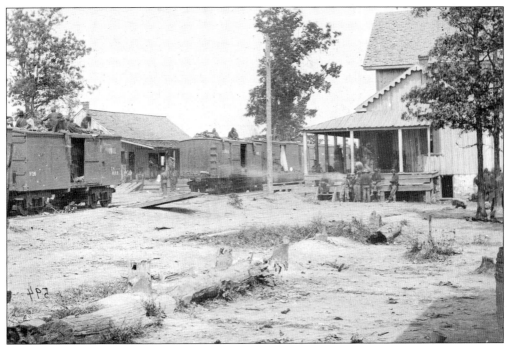

VILLAGE OF CATLETT. Gen. J. E. B. Stuart's troops captured 200 Union prisoners and $25,000 in the summer of 1862. The Confederates also nabbed Union general John Pope's personal items, including his dispatch book. Intelligence from the book enabled Robert E. Lee and Stonewall Jackson to develop a strategy that led to victory at the Second Battle of Manassas a week later. (LOC.)

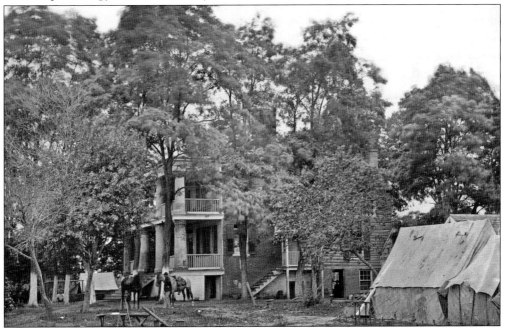

FAIRFAX COURTHOUSE. In 1862, the Union army took possession of the courthouse and the surrounding area for the duration of the war. The building, used as a military headquarters and a lookout station, was gutted by soldiers and many records destroyed. (LOC.)

WORKER REPAIRING TELEGRAPH LINE. The telegraph service was a civilian bureau attached to the army quartermaster's department. The men who performed the dangerous work in the field were mere employees, often treated with little consideration by the military. More than 300 operator casualties occurred during the war. (LOC.)

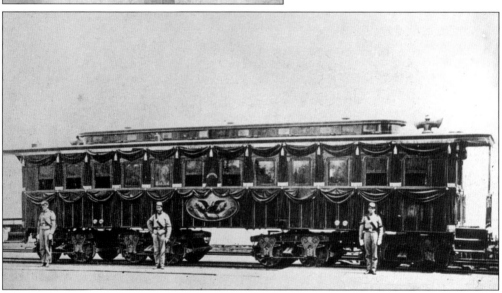

PRESIDENT LINCOLN'S FUNERAL CAR. "This whole community was startled this morning, early, by reports from Washington, of the murder of the President of the United States, and the attempted assassination of the Secretary of the State and his son. So astounding was the intelligence, that the rumor was at first discredited. No one believed that such an awful tragedy did or could happen," reported the *Alexandria Gazette*. (ALSC.)

Nine

AFTERWARD

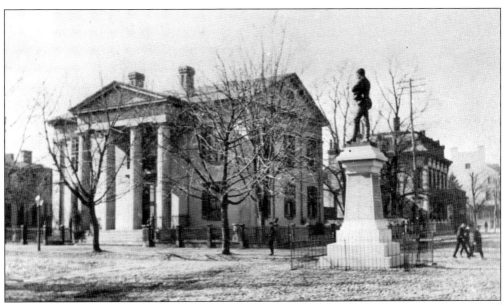

LYCEUM AND CONFEDERATE MONUMENT. At the conclusion of the war, the Union army gathered for a grand victory parade in Washington. On July 7, 1865, the military governor of Alexandria ceased his duties, and normalcy returned. The Lyceum was sold to John B. Daingerfield and remodeled into a fashionable residence for his daughter. After the death of its last residential owner in 1938, the home became an office building. By the late 1960s, plans were underway to demolish the Lyceum. Local preservationists saved the structure, which reopened as Virginia's first Bicentennial Center in 1974 and became the city's history museum in 1985. (ALSC.)

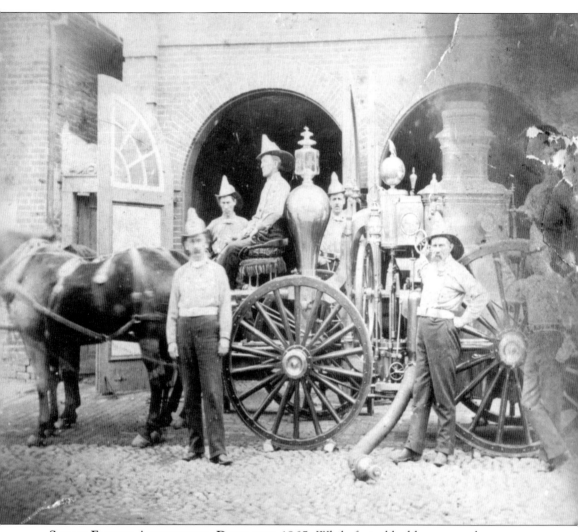

STEAM ENGINE AUTHORIZED, DECEMBER 1865. While forts, blockhouses, and army camps were being dismantled and military items sold, attention was now being transferred to the hazards of peacetime. Alexandria had been plagued by fires throughout its history. The town's tobacco warehouse was destroyed in 1853. In 1854, the town passed a zoning law prohibiting the construction of wooden buildings in certain areas. In spite of this law, a serious fire broke out in November 1855 in which seven volunteer firemen were killed when a burning building collapsed. The Union army maintained two steam fire engines during the occupation. The Alexandria City Council authorized purchase of one of the engines in December 1865. In 1866, the city council sanctioned the first paid fire department. It had three salaried firemen, with the lead fireman receiving $70 a month. (ALSC.)

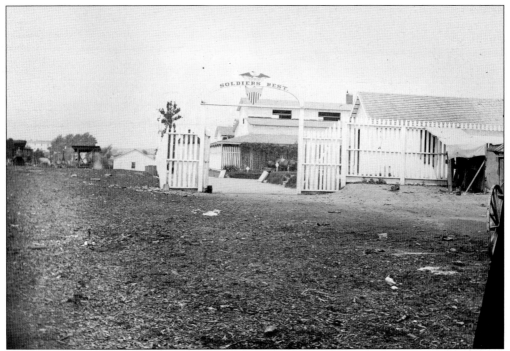

SOLDIER'S REST. According to the *Alexandria Gazette* of November 12, 1866, "The building and fences on the property at the upper end of Duke Street . . . and known latterly as Soldier's Rest, were disposed of on Saturday morning last, at public auction, by officers of the United States government, to gentlemen of this city, at comparatively cheap rates, and the buildings will be speedily removed." (LOC.)

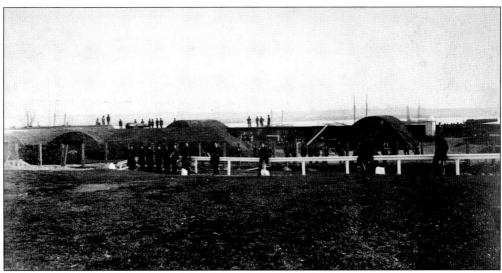

BATTERY RODGERS. The battery was dismantled and its guns removed to other locations in Washington. Because of its prime location in the center of Alexandria, the land was quickly sold. Today only a small marker remains where the battery once stood. Its giant Rodman gun was moved across the Potomac to Fort Foote, where it can still be seen. (LOC.)

CONFEDERATE RAIDER JOHN S. MOSBY. Mosby continued his activities unabated right to the end of the war, when he gathered his men one last time and disbanded, never officially surrendering to federal forces. Mosby went on to become a distinguished railway lawyer and took a prominent role in Reconstruction politics in Virginia. He died in 1916 at the age of 83. (LOC.)

MARSHALL HOUSE. The place where Elmer Ellsworth and James Jackson became martyrs to their respective causes survived the war (it was finally torn down in the 20th century). The Marshall House grew into a popular tourist site, and relic hunters had no qualms about cutting off bits of the famous hotel. (LOC.)

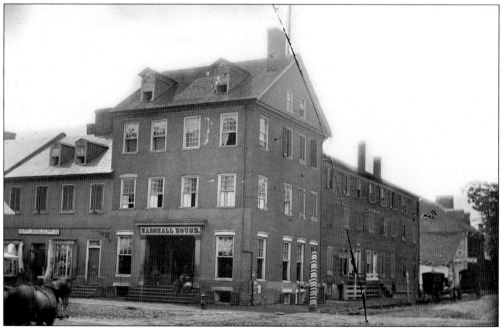

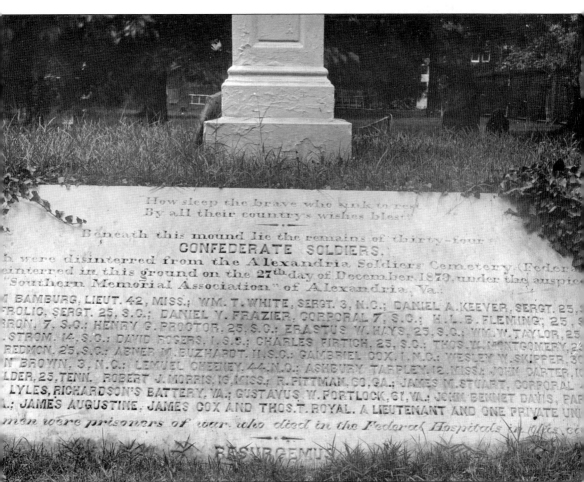

How sleep the brave who sink to rest
By all their country's wishes blest

Beneath this mound lie the remains of thirty-four
CONFEDERATE SOLDIERS.
who were disinterred from the Alexandria Soldiers' Cemetery (Federal)
reinterred in this ground on the 27th day of December 1879, under the auspices
"Southern Memorial Association" of Alexandria, Va.:

...M BAMBURG, LIEUT. 42, MISS.; WM. T. WHITE, SERGT. 3, N.C.; DANIEL A. KEEVER, SERGT. 25,...
...ROLIC, SERGT. 25, S.C.; DANIEL Y. FRAZIER, CORPORAL 7, S.C.; H. L. B. FLEMING, 25, S...
...RON, 7, S.C.; HENRY G. PROCTOR, 25, S.C.; ERASTUS W. HAYS, 25, S.C.; WM. W. TAYLOR, 25...
...STROM, 14, S.C.; DAVID ROGERS, 1, S.C.; CHARLES FIRTICH, 25, S.C.; THOS. W. MONTGOMERY, 2...
...REDMON, 25, S.C.; ABNER M. BUZHARDT, 11, S.C.; GAMBRIEL COX, 1, N.C.; WESLEY W. SKIPPER, 3...
...N BROWN, 3, N.C.; LEMUEL CHEENEY, 44, N.C.; ASHBURY TARPLEY, 12, MISS.; JOHN CARTER, 1...
...LDER, 25, TENN. ROBERT J. MORRIS, 16, MISS.; R. PITTMAN, CO. GA.; JAMES M. STUART, CORPORAL...
...LYLES, RICHARDSON'S BATTERY, VA.; GUSTAVUS W. FORTLOCK, 61, VA.; JOHN BENNET DAVIS, PAR...
...L.; JAMES AUGUSTINE, JAMES COX AND THOS. T. ROYAL. A LIEUTENANT AND ONE PRIVATE UNI...
men were prisoners of war who died in the Federal Hospitals...

RESURGEMUS

STONE AT BASE OF MEMORIAL IN CHRIST CHURCH. In the yard outside Christ Church, the 41-year-old George Washington declared to friends that he was prepared to fight for American independence. Christ Church was a hallowed place for the citizens of Alexandria. In the years following the Civil War, 34 Confederate soldiers were reinterred in the Christ Church cemetery. A marble plaque with the names of the fallen marks the mass grave. The Confederate troops who marched out of Alexandria in 1861 formed the nucleus of the 17th Virginia Infantry. Pvt. Edgar Warfield of the 17th started with the jovial and enthusiastic attitude shared by many Southern recruits embarking on the great adventure. These men would not see home again until 1865, after encountering many horrors and hardships. The Confederate fallen were remembered for their "courage, fidelity and patriotism." (ALSC.)

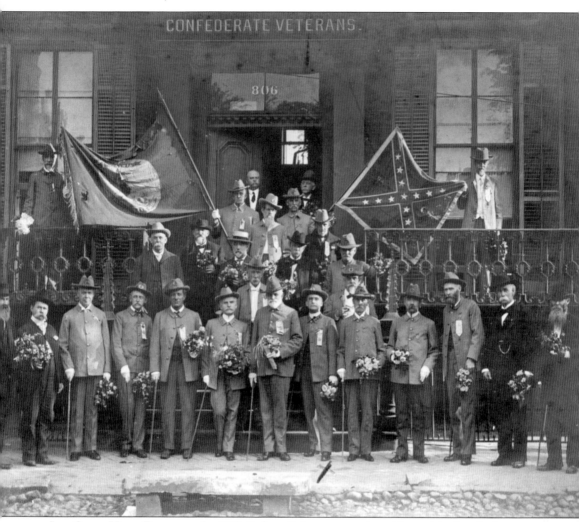

LEE CAMP HALL REUNION. In 1869, Robert E. Lee returned to Alexandria. Lee had not seen the city since 1861 and had come to visit family. He walked up King Street to the home of his mother's aunt A. M. Fitzhugh on Washington Street, where he met his brother Sidney Smith Lee and other relatives. A reception was held at Green's Mansion House. For hours, an unbroken line of friends shook Lee's hand. The *Alexandria Gazette* summarized the event: "It was more like a family meeting than anything else, for we here regard General Lee as one of our Alexandria boys." In 1870, Lee wrote, "There is no community to which my affections more strongly cling than that of Alexandria, composed of my earliest and oldest friends, my schoolfellows, and faithful neighbors." (ALSC.)

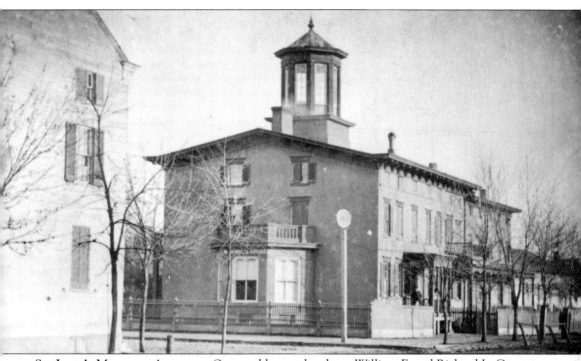

ST. JOHN'S MILITARY ACADEMY. Operated by two brothers, William F. and Richard L. Carne, the academy kept alive the memory of "the Cause." Cadets from St. John's Military Academy were often seen marching in parade formation through the streets of Alexandria. Richard L. Carne was appointed the first superintendent of Alexandria Public Schools in 1871. Public education remained segregated for almost a century. On November 5, 1888, the R. E. Lee Camp voted to seek approval from city council to place a statue in memory of the city's Confederate dead at the intersection of Washington and Prince Streets, the point from which the Alexandria troops had left. The council quickly granted permission. The dedication ceremony was held on May 24, 1889. Virginia governor Fitzhugh Lee, formerly a major general of cavalry in the Army of Northern Virginia and a nephew of Gen. Robert E. Lee, delivered the dedicatory address. (ALSC.)

CONFEDERATE MONUMENT. In April 1885, Edgar Warfield, a former private in Company H of the 17th Virginia, proposed to the R. E. Lee Camp of the United Confederate Veterans that a monument be erected to the Confederate dead of Alexandria. Artist John A. Elder of Fredericksburg submitted a clay model of the figure in his painting *Appomattox*, which was promptly accepted. (LOC.)

ALEXANDRIA NATIONAL CEMETERY. This cemetery serves as the final resting place for nearly 3,600 federal soldiers—3,367 white soldiers, 2 seamen, and 229 African American troops—2 female citizens, and 1 male citizen. Four men from the Quartermaster Corps who died in pursuit of John Wilkes Booth following the assassination of Pres. Abraham Lincoln are also buried here. (LOC.)

EDGAR WARFIELD. When he left Alexandria, Edgar Warfield was just steps ahead of the invading Union troops. In the next four years, he fought in most of the major engagements. He penned his memoirs when he was almost 90. About his return after the war, Warfield wrote, "We landed at Wheat's Wharf between Queen and Princess Streets. Here the four of us separated, each to make his way home that we had left four years before. I was delayed so much between the wharf and home by the friends I met on the way that on reaching the intersection of King and Water [now Lee] Streets, I turned up the latter street, and then made my way through Smoot's Alley to Fairfax Street. . . . We four were the first arrivals from the surrender at Appomattox." Warfield became Alexandria's oldest surviving Civil War veteran. (ALSC.)

DISCOVER THOUSANDS OF LOCAL HISTORY BOOKS
FEATURING MILLIONS OF VINTAGE IMAGES

Arcadia Publishing, the leading local history publisher in the United States, is committed to making history accessible and meaningful through publishing books that celebrate and preserve the heritage of America's people and places.

Find more books like this at
www.arcadiapublishing.com

Search for your hometown history, your old stomping grounds, and even your favorite sports team.